IMAGES
of America

SURFING
CORPUS CHRISTI
AND PORT ARANSAS

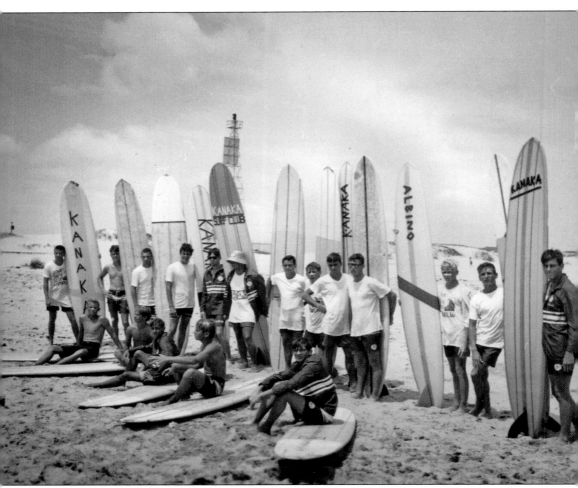

ON THE COVER: Corpus Christi's Kanaka Surf Team poses for a photograph portrait during an Easter 1966 surf contest at South Padre Island. From left to right, they are (first row) Joey Herr, Jackie Hoffman, Pat Magee, Danny Hunsaker, and Bob Watson; (second row) Pat Jewel, Greg Kiel, Armond "Doc" Jones, Jeff Kiel, Billy Kohler, Tony Mierzwa, Roland Hogan, Johnny Peel, Brent Flower, Bruce Stephens, Jimmy Kuddes, Terry Gill, and Ed Bounds. (Courtesy of Pat Magee.)

IMAGES
of America

SURFING
CORPUS CHRISTI
AND PORT ARANSAS

Dan Parker, Michelle Christenson,
and the Texas Surf Museum

ARCADIA
PUBLISHING

Published by Arcadia Publishing
Charleston SC, Chicago IL, Portsmouth NH, San Francisco CA

Printed in the United States of America

Library of Congress Control Number: 2009941026

For all general information contact Arcadia Publishing at:
Telephone 843-853-2070
Fax 843-853-0044
E-mail sales@arcadiapublishing.com
For customer service and orders:
Toll-Free 1-888-313-2665

Visit us on the Internet at www.arcadiapublishing.com

To all Texas wave riders—past, present, and future

CONTENTS

ACKNOWLEDGMENTS

More than 50 people and organizations provided photographs for this book, and dozens more supplied important historical information. We cannot thank them all in this space, but we would like to name some: Puddy Albright, Michael Boyd, David Burkhardt, G. Scott Ellwood, Frank Floyd, Jock Goodman, Eddie Harper, George Hawn, Patrick and Tippy Kelley, Doug Kinsley, Allen Lassiter, Pat Magee, Tony Mierzwa, Kent Savage, Cliff Schlabach, RoxAnne Bowen-Schlabach, John Trice, Elride.com, the *Corpus Christi Caller-Times*, and the *Port Aransas South Jetty*.

INTRODUCTION

Talk about waves of change. Before 1960, no surfing population existed in Texas, yet thousands of surfers inhabit the Lone Star State today. The central coast of Texas, also known as the Coastal Bend, boasts a surf scene as vibrant as any in the state. Hundreds of folks in the Corpus Christi and Port Aransas areas have devoted themselves to a pastime that supplies adrenaline-pumping fun and even defines entire lifestyles. The sport's popularity in Texas—a place not usually associated with strong surf—serves as a commentary on the power of the physical and spiritual experience of riding waves, even when they are small and without punch. Surfing's endurance in the Lone Star State also testifies to something that all devoted Texas surfers know: on a given day, the surf here can produce long, curvaceous, surprisingly powerful waves that break in water that is far warmer and less crowded than can be found at California beaches.

Until the early 1960s, surfing in the Coastal Bend was something done only sporadically, by perhaps one or two individuals at a time, here and there. There was no surf scene, per se. Surfing developed in the Coastal Bend and throughout the rest of the Texas coast for the same reason the sport took off in many other areas of the world. It was part of an international reaction to a combination of factors. The novel and movie versions of *Gidget*, based on a teenaged girl's introduction to surfing in California, captured the imaginations of millions in the late 1950s. Surf magazines were founded in Southern California in the early 1960s, and their circulations reached Texas. Bands like Jan and Dean and The Beach Boys called attention to surfing as a cool and exciting sport.

By many accounts, Corpus Christi residents Cecil Laws and his son, Larry Laws, planted the seeds that sprouted a surfing subculture in the Coastal Bend. The two were inspired after taking surfing lessons while visiting Hawaii in 1962. When they got home, Cecil ordered several surfboards from California. At first, they intended them simply for personal use. Soon, however, they decided to start renting the boards out. Larry conducted the operation on the beach near Bob Hall Pier.

"I've never had as much fun, to tell you the truth," Larry Laws said in an interview with the Texas Surf Museum in May 2005, four years before his death. "Going out there, watching the sun come up and hanging out on the beach, meeting great people and going home at the end of the day, toasted by the sun, it was a great life. It was kind of the age of innocence. Things were still good. . . . It was a great ride."

As more folks rented from Larry and the national captivation with surfing continued, more rental stands appeared in the Coastal Bend. Surf shops and surfboard makers sprouted in Corpus Christi and Port Aransas. Coastal Bend surf clubs formed. Local surf magazines were established. Surf contests were organized. Statewide, the Gulf Coast Surfing Association was formed, then the Gulf Surfing Association, the Texas Surfing Association, and the Texas Surfing Association. Surfing started in the early 1960s as a kids' sport, then became associated with the counterculture movement of the late 1960s and early 1970s. As surfers of the baby boomer era aged, many became

professionals and politicians but hung on to their surfing roots, still riding waves as their hair grayed. They passed the sport on to their children. By the new millennium, three generations of surfers were riding waves together at Coastal Bend beaches. Hundreds, perhaps thousands, were taking part in the pastime.

Coastal Bend surfers made their marks on the national surf scene. Corpus Christi surfers won national championships in surf contests, beating out surfers from California, Hawaii, and the East Coast. In the 1970s and 1980s, Pat Magee of Port Aransas emerged as one of the state's best-known surf shop proprietors and classic surfboard collectors. Photographers began training their lenses on Coastal Bend surfers, and the resulting images were published in international magazines. In 1976, Corpus Christi's John Trice established what is believed to be the nation's first surf shop ever to be located in an indoor mall. National surfing championship contests were held in the Coastal Bend. Cliff Schlabach of Corpus Christi served as vice president of the U.S. Surfing Federation from 1988 to 2000. In 2004, the Texas Coastal Bend chapter of the Surfrider Foundation was formed to protect surfers' interests in beach access and water quality. In 2005, the Texas Surf Museum opened its doors in downtown Corpus Christi, celebrating the state's place in surfing history and drawing thousands of visitors from around the world during the institution's first few years of existence.

All of this is remarkable, but it is not what has kept Coastal Bend surfers in the water for decades. Their inspiration is paddling out through bath-warm water at dawn while watching emerald-green waves crash and the sun rise over the Gulf of Mexico. It is watching brown pelicans glide in formation over the beach. It is waiting with frustration through a weeks-long flat spell and then enjoying the thrill of riding powerful hurricane surf. It is hanging out on the beach with surf buds and talking about how the Dallas Cowboys and Houston Texans have been playing or how the redfish and trout have been biting in local bays. It is paddling out again at the end of the day and sitting, waiting for just one more wave, while watching the sun set behind the sand dunes on Padre and Mustang Islands and knowing there always will be more waves in the days to come.

One

SURF SPOTS

Facing the Gulf of Mexico, about 40 miles of beaches line the Texas Coastal Bend, an area defined by most residents as beginning on San Jose Island, stretching throughout the length of Mustang Island, and ending within Padre Island National Seashore.

All Coastal Bend surf breaks on sandbars, not on reefs or rocks, as do waves in some other parts of the world. When there is a swell, waves are ride-able throughout the Coastal Bend, but certain spots have better wave quality. Sandbars tend to accumulate close to structures like piers and jetties, often producing shapelier, more consistent, and harder-breaking waves.

Though they all break on sandbars, the Coastal Bend's surf spots still boast great variety. Unpopulated San Jose Island possesses great natural beauty and no public conveniences, (not even running water); only about a mile away, Horace Caldwell Pier lies within the small town of Port Aransas, on Mustang Island, where tens of thousands of tourists visit on weekends. Farther south, Bob Hall Pier is a more urban break, lying within the city limits of Corpus Christi, a city with close to 300,000 residents in 2009.

Man-made structures have figured prominently in the creation of Coastal Bend surf spots but in different ways. A pier-like structure was built in the early 1980s as the centerpiece of J. P. Luby Surf Park, specifically to forge good waves for surfers. Then, in the new millennium, the pilings were removed to make way for the extension of Packery Channel to the Gulf of Mexico. The channel was dredged to create an outlet to the gulf in hopes that a resort development would be constructed there, but the jetties built at the channel incidentally created a good surf break. Likewise, jetties built in the 1970s with the dredging of the Fish Pass, on Mustang Island, created popular breaks.

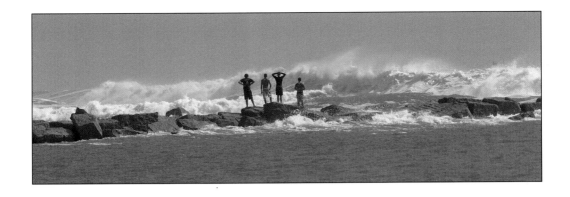

Above, four surfers stand on the North Jetty watching big waves break at San Jose Island during the Hurricane Ivan swell in 2004. The 21-mile-long San Jose Island, also known as St. Joe, is privately owned by the wealthy Bass family of Texas, but surfers and tourists are allowed to visit the southern end of the island. The island is undeveloped, except for a small ranch complex miles from public areas. Below, surfers Tony and Sue Mierzwa (left) and Steve Stephenson take a ride in 1969 on the jetty boat, which for years has ferried people between San Jose Island and Port Aransas, on Mustang Island. (Above, photograph by Michelle Christenson, courtesy of the *Corpus Christi-Caller-Times*; below, courtesy of Tony Mierzwa/Down South Collection.)

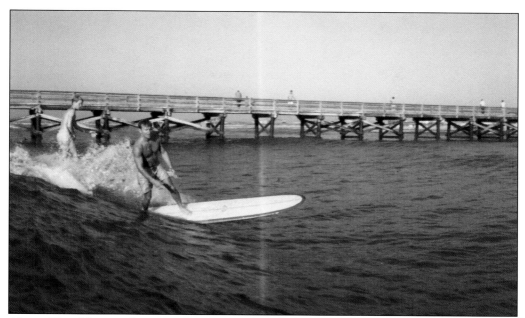

Above, Tony Mierzwa, foreground, and an unidentified surfer ride a wave at Horace Caldwell Pier in Port Aransas on a mid-1960s day. The pier has been a favorite spot since surfing first came to Port Aransas in the early 1960s. Originally a wooden pier, it was replaced by a concrete pier after being heavily damaged by Hurricane Allen in 1980. Below, a surfer at the pier surveys the scene before paddling out in heavy surf generated by Hurricane Dolly in 2008. Surfing for years was illegal within 200 feet of the pier, but the Port Aransas City Council overturned the law in 1997. Councilmember Mary Goldsmith (mother of stand-out Port Aransas surfer Morgan Faulkner) led the charge to change the law. (Above, courtesy of Margaret Ellison; below, photograph by Dan Parker, courtesy of the *Port Aransas South Jetty*.)

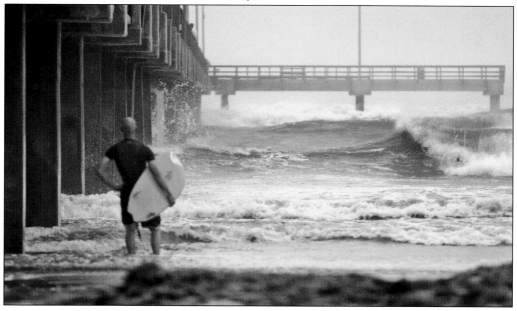

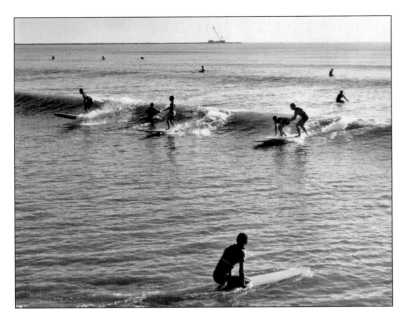

Four surfers take off on a wave while one paddles out on his knees, old-school style, on a glassy day at Horace Caldwell Pier in Port Aransas in the mid-1960s. While a good number of Port Aransans surfed in the 1960s, they were joined by many Corpus Christi surfers who made the 45-minute drive to surf at Horace Caldwell Pier. (Courtesy of Tony Mierzwa/Down South Collection.)

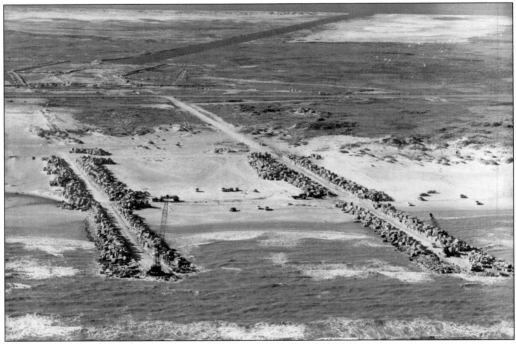

Cranes in 1971 build granite jetties on each side of what would end up being a channel called the Fish Pass, dredged through Mustang Island. The jetties created new surf breaks that became highly popular. The channel gradually silted in until it closed completely by the mid-1980s, and no further efforts were made to dredge it. (Courtesy of the *Corpus Christi Caller-Times*.)

An unidentified surfer rides a wave near the Fish Pass while workers dump a truckload of rocks to help build a jetty bordering the pass in November 1971. Perhaps the most favored spot at the Fish Pass was at the north jetty, where a thick peak commonly wedged up. Surfers also rode waves between the jetties and at the south jetty. (Photograph by Doug Kinsley.)

Spectators observe the surf action from a newly built jetty at the Fish Pass on a day in the early 1970s. Perhaps more than any other Coastal Bend spot at the time, the north Fish Pass jetty served as an amphitheater for audiences eager to watch wave-riding performances unfold in a crowded and narrow take-off zone where collisions and disputes between surfers were common. (Photograph by Doug Kinsley.)

J. P. Luby (then a Nueces County commissioner) and surfer Norman Miller examine a piling that was to be used in construction of J. P. Luby Surf Pier on North Padre Island in January 1984. Few if any other beach structures in the world ever had been built for the sole purpose of producing waves for surfers. (Photograph by Lee Dodds; courtesy of the *Corpus Christi Caller-Times*.)

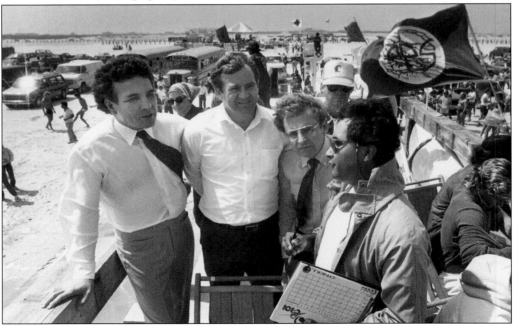

From left, deputy land commissioner Arnold Gonzales, Texas attorney general Jim Mattox, and Nueces County commissioner J. P. Luby talk with surf contest judge Eric Salazar after opening ceremonies at the newly constructed J. P. Luby Surf Pier on March 30, 1984. (Photograph by Lee Dodds; courtesy of the *Corpus Christi Caller-Times*.)

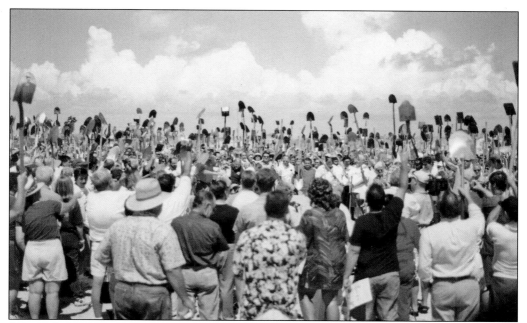

Scores of supporters raise shovels skyward during groundbreaking on August 19, 2003, for a project to dredge Packery Channel. The channel was a small waterway on North Padre Island until Corpus Christi city officials pushed through a project to dredge the channel several hundred yards to the Gulf of Mexico. The project's jetties created good surf spots. (Courtesy of Patrick Kelley.)

Nicole Dodson of Corpus Christi paddles up the shoulder of a big, hollow wave at Packery Channel on December 18, 2005. Construction of Packery Channel did not lure the multimillion-dollar resort development that officials had hoped for—at least not right away—but surfers flocked to the spot to ride its waves. (Courtesy of G. Scott Imaging.)

Delwin O'Kelly surfs a North Padre Island surf spot known as Million Dollars in the 1970s. Million Dollars was named for the hotel on shore, the Million Dollar Inn. "It had a hard-hitting second bar," recalled longtime Corpus Christi surfer Michael Boyd. "When it got big, overhead, there were big, green walls." (Courtesy of Patrick Kelley.)

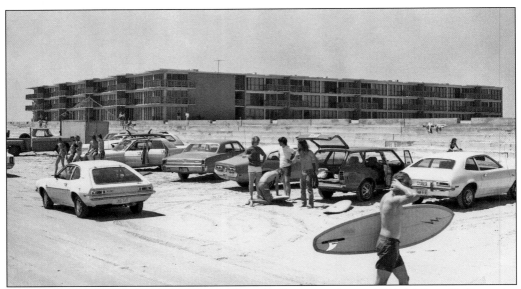

Surfers congregate near the seawall at Million Dollars on a day in 1974. Million Dollars, also known as Condos, was popular because it had good waves, and the spot did not present the hassles of surfing nearby Bob Hall Pier, where it was illegal to surf and fishermen could become belligerent. (Courtesy of the *Corpus Christi Caller-Times*.)

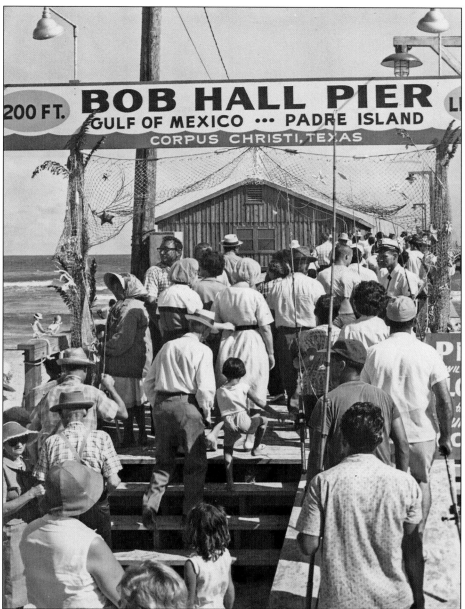

Fishermen crowd onto Bob Hall Pier after dedication ceremonies for the rebuilt structure in 1962. Named after a Nueces County commissioner, the pier originally was built 300 feet long in 1950. The pier was extended to 600 feet in 1952, but Hurricane Carla destroyed it in 1961. After the 1962 reconstruction, the structure was 1,200 feet long, with three T-heads. Hurricane Beulah wiped out 400 feet of the pier in 1967, and it was reopened the following year as an 800-foot pier with T-heads in the middle and at the end. Hurricane Allen decimated the pier in 1980, and reconstruction of a $1.3-million concrete pier began in 1982. The new structure was 1,240 feet long and had one T-head. Anglers have hooked everything from trout to sharks, including a monster 1960s-era catch: a tiger shark 13 feet, 7 inches long. (Courtesy of the *Corpus Christi Caller-Times*.)

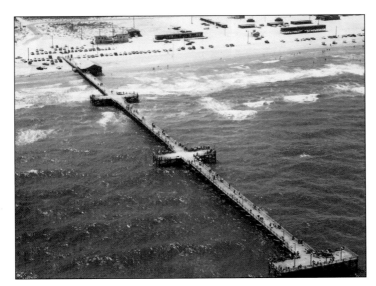

Bob Hall Pier juts into waters off North Padre Island in 1965. In the early 1960s, when Coastal Bend surfing was in its infancy, fishermen on the pier applauded when they first saw people riding waves there, veteran Corpus Christi surfer Tony Mierzwa recalled. Soon, however, anglers and surfers began arguing over turf, and relations between the groups stayed strained for decades. (Courtesy of the *Corpus Christi Caller-Times*.)

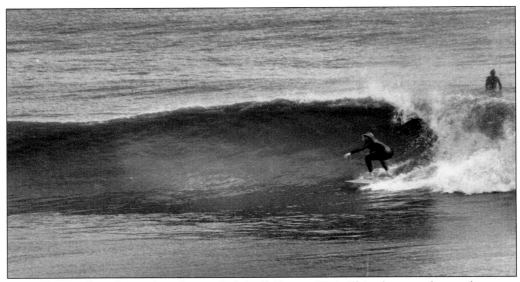

Doug Foster rides a long, clean line at Bob Hall Pier in 1971. This photograph was shot on a Wednesday that became known to some as "Big Wednesday," when overhead waves poured through the Coastal Bend. The pier, at the time, was a low-slung wood structure that largely blocked southeasterly winds, making surf on the north side of the pier glassier. (Photograph by Doug Kinsley.)

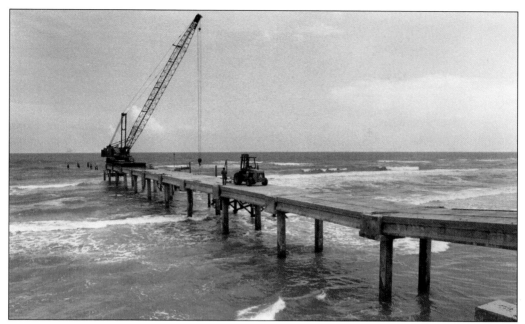

A crane rebuilds Bob Hall Pier in 1982 after it was demolished by Hurricane Allen. While surfing normally was illegal close to the pier, surfers were largely free to ride waves there while it was closed to fishermen due to the hurricane damage. County authorities resumed enforcing the law again after the new pier opened in 1983. (Courtesy of the *Corpus Christi Caller-Times*.)

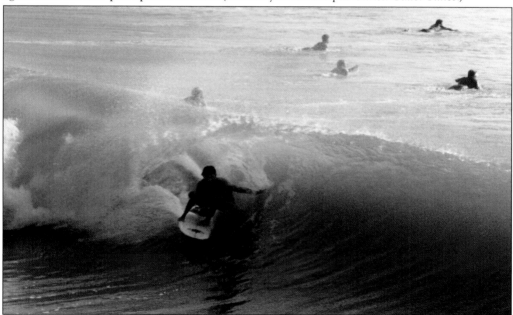

Frank Floyd rides an exceptionally clean and hollow wave at Bob Hall Pier during the Tropical Storm Frances swell in 1998. Whether a storm swell was present or not, Bob Hall Pier waves long have been capable of showing good, powerful form. It was one of the most popular spots in the Coastal Bend. (Photograph by Julie Polansky.)

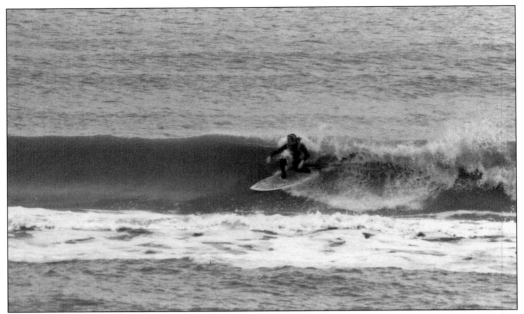

John Johnson streaks along a wave at Malaquite Beach at Padre Island National Seashore in 1979. The seashore is largely a wilderness that is inaccessible except by four-wheel-drive vehicles. Coastal Bend surfers long have driven the 70-mile length of the seashore to surf at the remote Port Mansfield jetties. (Photograph by David Burkhardt.)

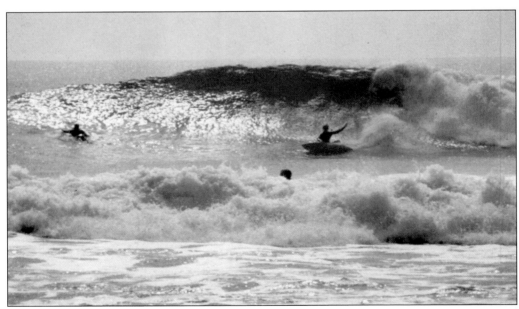

Phillip "Puddy" Albright carves a bottom turn at Malaquite Beach at Padre Island National Seashore on a day in the early 1970s. Thanksgiving surf contests were held at Malaquite in the early 1970s. The Gulf Coast Surfing Championship at Malaquite drew surfers from all over Texas and Florida in 1970. (Courtesy of Puddy Albright.)

Two

SURFERS

It is hard to know who first surfed the Coastal Bend. Indications are that no surfboards were commercially available on the Texas coast before 1960. Anyone who rode Coastal Bend waves in the 1950s or prior probably imported a board from somewhere like California, where boards had been sold at retail outlets since the early 1950s. The earliest person known to surf the Coastal Bend was B. L. "Chip" Guess III, a teenager who made a wooden surfboard in his parents' Corpus Christi garage in the early 1950s. Although he rode the board only a few times before tiring of the sport and quitting, his efforts remain historic. His wooden board went on display at the surf museum in 2005.

When a surf boom erupted throughout the world in the early 1960s, surfers of the Lone Star State evolved as a different breed. Texas surfers love surfing so much that they are willing to endure long flat spells and surf junk for weeks or even months before a good swell comes along. And, since Texas surf spots as a rule do not have calm channels for easy paddles out, surfers here became a tough group, developing the ability to paddle hundreds of yards, spearing through dozens of breaking waves to reach desired take-off zones far from shore.

Coastal Bend surfers persevered, and their love of the sport took them many places. It took them into the troughs of large hurricane-generated waves that relatively few Texans ever had seen up-close before. It took them to state and national championships in surf contests. It took them into the political arena, where they lobbied elected officials for the right to surf beside piers. It took them into the realm of community activism that influenced hundreds of voters in Corpus Christi city elections. And it took them on migrations that inserted a little bit of Texas surf culture in every coastal state in the nation, including Hawaii—the spiritual birthplace of surfing.

B. L. "Chip" Guess III poses for a photograph in October 2009 with a wood surfboard he made as a boy in Corpus Christi in the early 1950s, when few if any other individuals were surfing the Coastal Bend. He rode the board one or two times near Bob Hall Pier, then stored it away for years before donating it to the Texas Surf Museum. (Photograph by Michelle Christenson.)

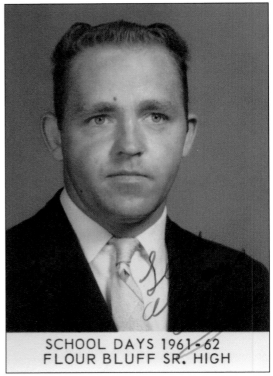

Allen Blackard appears in a 1962 Flour Bluff High School senior portrait. Blackard lived his teenage years in Port Aransas, except for his junior year of high school, when he lived in Hawaii from summer 1960 to August 1961, after which he moved back to Port Aransas, bringing a balsa board back with him. Surfing was practically unknown in Port Aransas, and Blackard surfed largely alone. (Photograph courtesy of the Blackard family.)

SCHOOL DAYS 1961-62
FLOUR BLUFF SR. HIGH

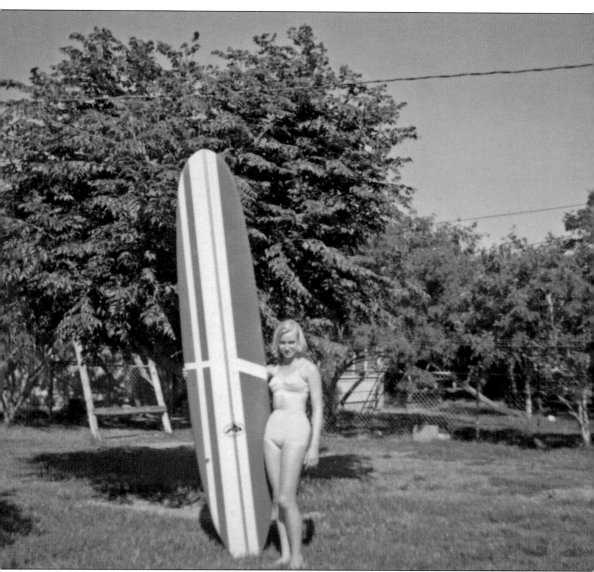

Eighteen-year-old Donna Slaughter poses in her Corpus Christi backyard with her Orca surfboard in May 1964. Donna was introduced to surfing when her family visited Southern California on vacation in the summer of 1961. She and a friend, Anna McKenzie, got surf lessons at La Jolla. Anna's father bought them surfboards and brought them back to Corpus Christi, where surfboards were almost unknown at the time. Surfing was mostly a Californian and Hawaiian phenomenon. Donna surfed at North Padre Island a lot when she got back to Texas. More Texas folks started riding waves in the early to mid-1960s, as a surfing craze began to grip coastal areas throughout the world. As clubs and teams popped up in the Corpus Christi area, Donna became a charter member of the Kanaka Surf Club, South Wind Surf Club, and Copeland Surf Team, winning a number of surf contests. (Photograph courtesy of Donna Gough.)

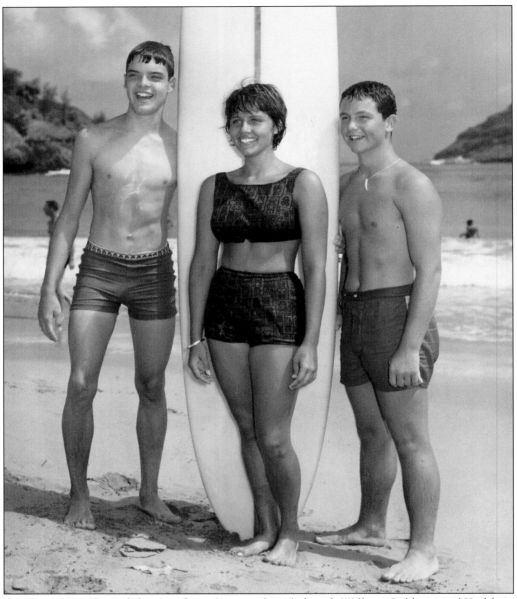

A teenage Larry Laws, left, poses for a photograph with friends William Goldston and Kathleen Jones in Hawaii in 1962. Larry, his mother, Ruth, and his father, Cecil, got surf lessons while visiting Hawaii. Later that year, back home in Corpus Christi, Cecil imported about 10 surfboards from California and started a North Padre Island board rental business, representing some of the first boards commercially available in the Coastal Bend. Larry was the face of the board-rental business, spending many days on the beach, conducting the rental enterprise, while Cecil worked behind the scenes as the businessman. Many Coastal Bend residents got their first tastes of surfing by renting surfboards from Larry. For some, the experience ignited a lifelong passion. Among those who learned with Laws' boards were Tony Mierzwa, who later established Down South Surf Shop in Corpus Christi, and Pat Magee, who eventually owned surf shops bearing his name in Port Aransas and many other Texas cities. (Courtesy of Cecil Laws.)

Corpus Christi's Cecil Laws, pictured here in 1967, started a surfboard rental operation just south of Bob Hall Pier in 1962. "I was the first," Laws said in an interview nearly 50 years later. "No one else even knew what a surfboard looked like." Laws expanded his operation to Galveston and South Padre Island before closing it all down around 1967. (Photograph courtesy of Ruth Mizell.)

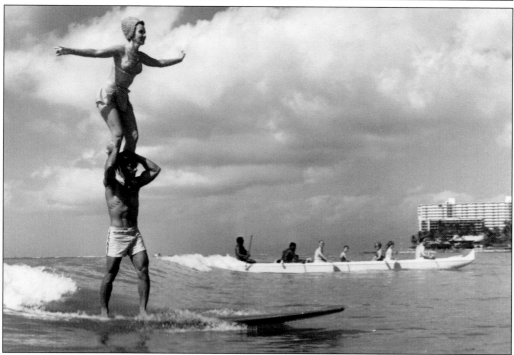

Ruth Laws of Corpus Christi balances on the shoulders of champion Hawaiian surfer Bobby Ah Choy during a surf lesson at Waikiki Beach on Oahu in 1962. This photograph was taken by noted photographer Clarence Maki, who shot landmark Hawaiian surf photographs of the 1950s and 1960s. Maki was the last person to shoot a photograph of the revered Duke Kahanamoku riding a wave. (Photograph by Clarence Maki.)

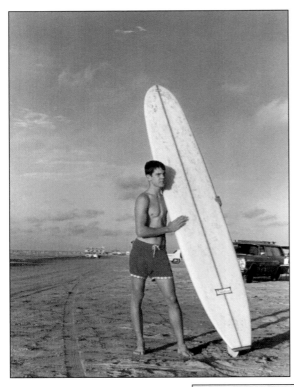

John White poses with a board on North Padre Island in the early 1960s. An early Coastal Bend surfer, White was valedictorian of Corpus Christi's Ray High School in 1965. The same year, he won a Port Aransas surf contest that drew 91 wave riders from all over the state's coast. White was murdered in 1969 while he was attending the University of Texas. (Courtesy of Jack and Lynn White.)

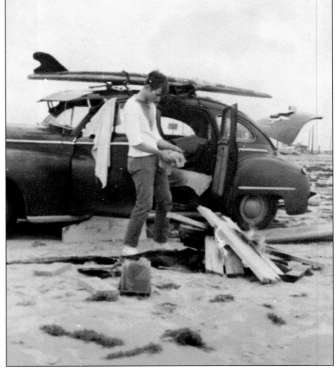

With his late-1940s Dodge D-24 sedan, Butch Moomey of Corpus Christi gets warm next to a fire on the beach on North Padre Island on a winter day in the mid-1960s. "Sometimes we'd sleep there on the beach and get up early and have a fire to keep warm," recalled Moomey's friend, Kent Savage. (Photograph by Kent Savage.)

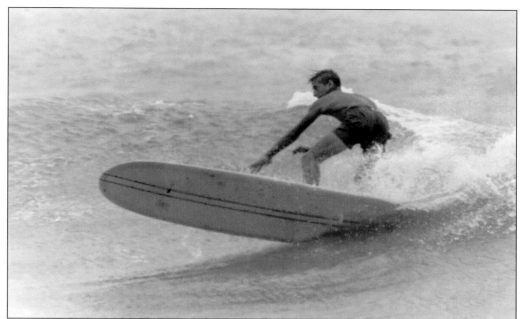

Pat Magee makes a hard bottom turn during a mid-1960s Coastal Bend surf session. Magee started surfing when he was a Corpus Christi boy in the early 1960s. He went on to win the Texas state championships in 1969 and 1970. Legendary California surfer Dewey Weber made Magee a national Weber team member from the late 1960s through the mid-1970s. (Courtesy of Pat Magee.)

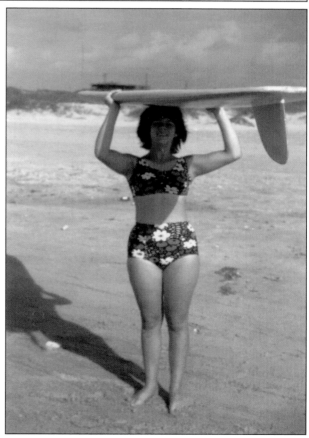

A teenage Paulette Just balances a board on her head in an early-1960s photograph shot in Port Aransas. Born and raised in Port Aransas, Just got started surfing on Mustang Island in the early 1960s. After joining up with the Copeland's surf team out of Corpus Christi, she won a number of surf contests along the Texas coast. (Courtesy of Paulette Just/Egeli.)

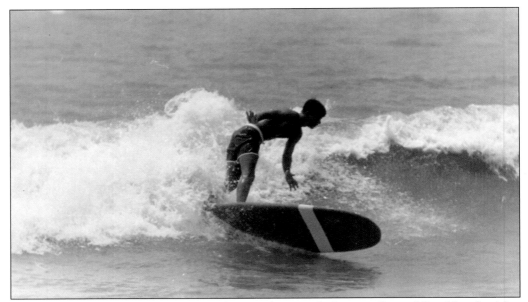

Jay Foley cranks off a hard turn in a mid-1960s photograph shot at a Coastal Bend beach. After getting his start as a surfer in the Coastal Bend, Foley migrated to the Santa Barbara surf scene in California and eventually to Byron Bay, Australia. "His style was graceful," friend Kent Savage recalled years later. "He's an artist, and his surfing was artistic. He drew beautiful lines." (Photograph by Kent Savage.)

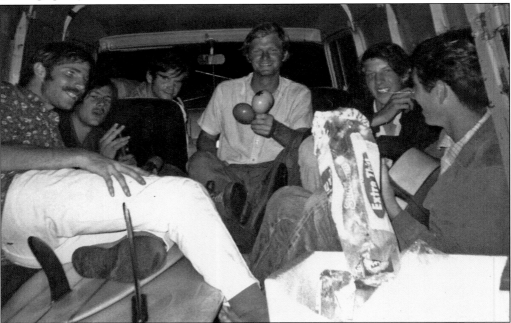

A group of friends gather in the rear of Kent Savage's van during a rainstorm on the beach in Port Aransas in the mid-1960s. From left to right are Jock Goodman, Bruce Wolf, Paul Jarmon, Jimmy Corder (with maracas), and two unidentified folks. Savage and Goodman were among the earliest serious Texas surf photographers. (Photograph by Kent Savage.)

From left to right, Danny Hunsaker, Brent Flower, Tony Mierzwa, and Greg Kiel pose with Mierzwa's Volkswagen, loaded with boards, in August 1966. Photographed at Mierzwa's Corpus Christi home, the young men were about to leave on a surf trip to California. Surfing safaris have long been important to surfers—especially Texas surfers. (Courtesy of Tony Mierzwa/Down South Collection.)

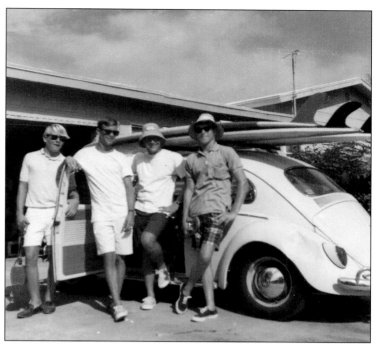

From left to right, Conrad Masters, Pete Eldridge, Joe Alley, and Steve Neely line up for a portrait in the summer of 1965 in Port Aransas. All four were friends who attended Corpus Christi's Ray High School. Driving 45 minutes to Port Aransas to surf on weekends was a little adventure, Alley said. "We would spend the night in our cars," he said. (Courtesy of Joe Alley.)

At left, Tippy Kelley of Corpus Christi poses for a photograph with her first surfboard in 1966. Few Coastal Bend residents have achieved more in the world of surfing than Kelley and her husband, Pat. Tippy's highlights include 58 first-place finishes in surf contests, 19 Texas state titles, and four national titles, beating out top women surfers from California, Hawaii, and the East Coast. The Kelleys have run Dockside Surf Shop in Corpus Christi since 1994. Tippy was one of the founders of the Texas Gulf Surfing Association in 1988. Pat also served as a Texas surf contest judge for more than 25 years, beginning in the 1970s. Below, Pat rides a Coastal Bend wave in 1979. (Photographs courtesy of Patrick Kelley.)

Pat Harral (foreground) and an unidentified surfer are featured on the cover of a Corpus Christi area tourism guide published in 1969 by the Corpus Christi Area Tourist Bureau. Harral, of Corpus Christi, was one of the Coastal Bend's first surfers, getting started about 1962. He was crowned state champion in 1967 and 1968 surf contests. (Courtesy of Donna Gough.)

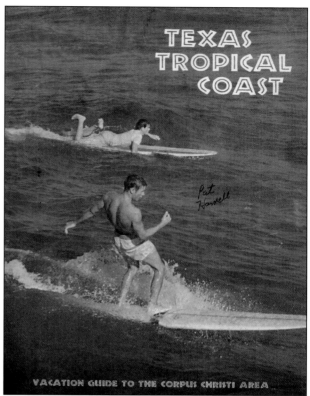

From left to right, Jim Carter, Joe Olvey, Duke Ulrich, and Kent Savage, all of Corpus Christi, pose next to Savage's van in a c. 1966 photograph on a Coastal Bend beach. Savage drove vans throughout his surfing years, and they served him well as he traveled with friends on surf trips up and down the Texas coast and out to California. (Courtesy of Kent Savage.)

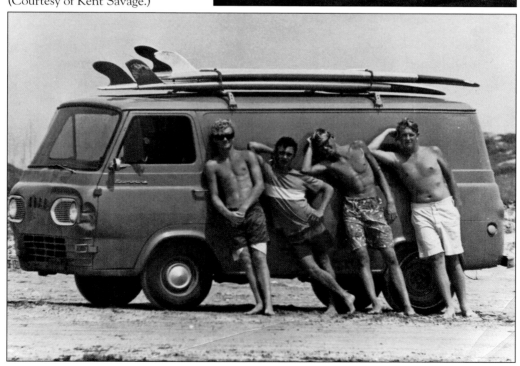

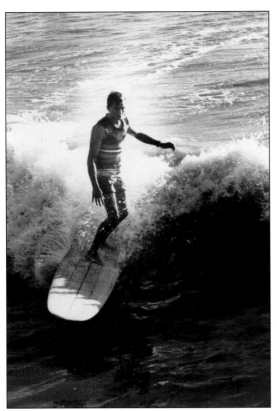

Brent Flower surfs at Horace Caldwell Pier in Port Aransas in 1966. Flower, of Corpus Christi, started surfing in the early 1960s and was a member of the Kanaka Surf Club. In 1965, he and Tony Mierzwa established Down South Surf Shop in Corpus Christi. (Courtesy of Tony Mierzwa /Down South Collection.)

DeDe Hunsaker sits in front of a Corpus Christi surf shop in 1966. Hunsaker started surfing in 1967 in Port Aransas. Forty-one years later, she lived in Oregon and was not surfing much anymore. But, she said, "I will be a surfer in my heart and my soul until I step through the veil to the other side." (Courtesy of Dorothy Turnbull Hill.)

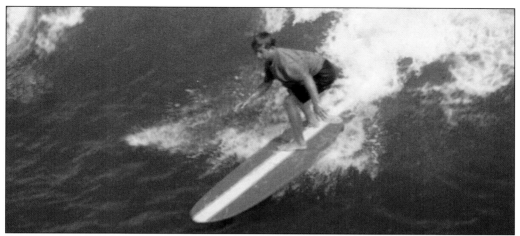

Jackie Hoffman surfs at Horace Caldwell Pier in Port Aransas in 1967. "Jackie was a really good surfer," friend Mike Gollihar remembered. "He really had the true cool surfer look and backed it in the water." Hoffman met several top California surfers—Tom Leonardo, Herbie Fletcher, and others in Texas and later moved to Huntington Beach and surfed with that group for several years. (Photograph by Bob Watson.)

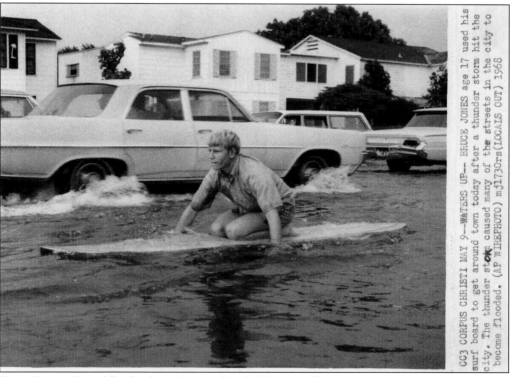

CC3 CORPUS CHRISTI MAY 9--WATERS UP-- BRUCE JONES age 17 used his surf board to get around town today after a thunder storm hit the city. The thunder storm caused many of the streets in the city to became flooded. (AP WIREPHOTO) mjl730rs(LOCALS OUT) 1968

Bruce Jones, 17, paddles his board over a flooded Corpus Christi street after a storm one day in 1968. This photograph was shot by Murray Judson, then a photographer for the *Corpus Christi Caller-Times*. The caption on one side of the photograph was typed in the style commonly used when a photograph was being put on the Associated Press wire. (Courtesy of the *Corpus Christi Caller-Times*.)

At left, friends Robert Rudine (front) and Douglas Foster walk up the beach during an early-1970s surf session. Growing up in Corpus Christi, Rudine won a state championship in the boys' division when he was 14 years old. He went on to become an accomplished big-wave rider, living for years in Hawaii and Petacalco, Mexico. His experiences in huge surf left him with many injuries over the years, including busted eardrums, broken bones, and wounds that required many dozens of stitches. A custom woodworker, Rudine has collaborated with shapers B. J. Williamson of Houston and Dick Brewer of Hawaii to create balsa and redwood surfboards. Below, Rudine surfs Bob Hall Pier in the early 1970s. (Photographs by Doug Kinsley.)

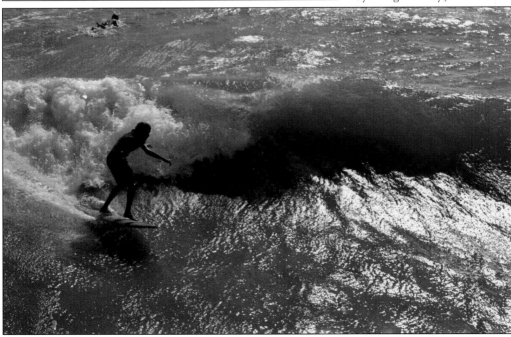

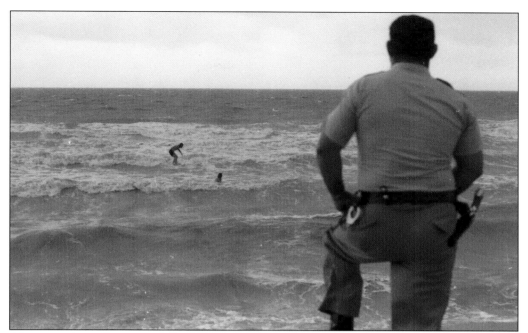

Above, a police officer atop the seawall on North Padre Island watches surfers riding waves during the early 1970s. It was legal to surf at the seawall, but police arrested people for surfing too close to Bob Hall Pier, a short distance north. "Court, the whole gig," recalled surfer Richard Powers. "We're, like, 14 years old, and the fishermen are putting heavy lead weights (on) and having bets on who can conk one of us surfers on the head with the weights. There were fights, yes, a lot, with the fishermen." Newspaper articles ran about surfers being arrested for surfing too close to Bob Hall Pier and Horace Caldwell Pier in Port Aransas. Below, Port Aransas surfer Jimmy Gates talks with a man on a pier in a 1970s-era photograph. (Photographs by Doug Kinsley.)

Doug Kinsley poses for a portrait with his 9-foot, 6-inch Yater while visiting the Fish Pass on Mustang Island in 1975. Kinsley lived and surfed in the Corpus Christi area only from 1969 to 1972, but he made lasting impressions with his photography. His images captured key players and events in the early-1970s Coastal Bend surf scene. (Courtesy of Doug Kinsley.)

Doug Kinsley surfs Bob Hall Pier in an early-1970s photograph. During that time, Kinsley shot photographs while flying over North Padre Island, capturing images showing how sandbars near the pier created superior surf. He used the photographs in a presentation he and other young surfers made in efforts to persuade Nueces County authorities to change a law banning surfing near Bob Hall Pier. (Photograph by Richard Powers.)

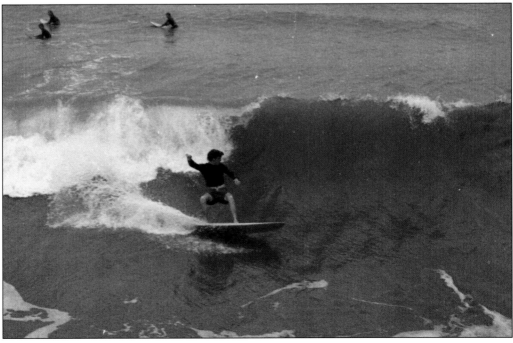

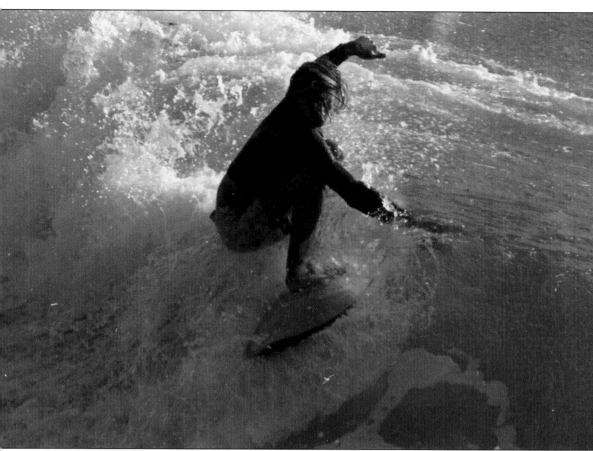

Richard Powers drives the length of a wave at Bob Hall Pier in an early-1970s photograph. Powers, of Corpus Christi, started surfing in 1967, when he was about 12 years old. One day when he was about 14, he was at the beach and found a wallet that belonged to an older surfer named Johnny Cobb. After returning the wallet, he started surfing with Cobb. "Hanging out with Johnny was like going to surf school," Powers said. "I learned a lot from him and met lots of people like Doug Kinsley, Robert Rudine, David Hudson, and a host of others that quickly became my friends." Powers started winning contests, and he met high-profile California surfer Mike Purpus, who helped him win a Bing Surfboards sponsorship. Powers also signed with Channin and Jacobs surfboards. He competed in surf contests in California, Hawaii, Florida, and Peru and lived in Hawaii for a time, surfing huge waves on the North Shore of Oahu. By 1992, he had moved to Costa Rica, where he continued to surf. (Photograph by Doug Kinsley.)

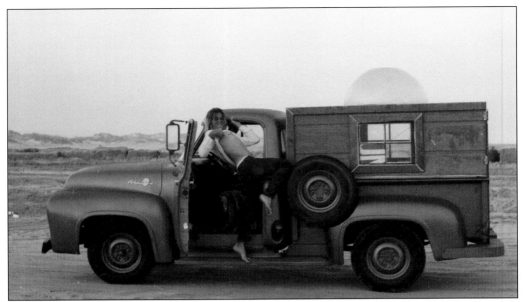

Corpus Christi surfer Pat Judd clowns on the beach with a borrowed truck about 1970. The truck belonged to some of Judd's visiting California friends who left the vehicle at Judd's house and continued their vacation farther south, in Mexico. "The truck got a lot of attention," Judd recalled. "Note the bubble on the top of the homemade bed." (Photograph by Doug Kinsley.)

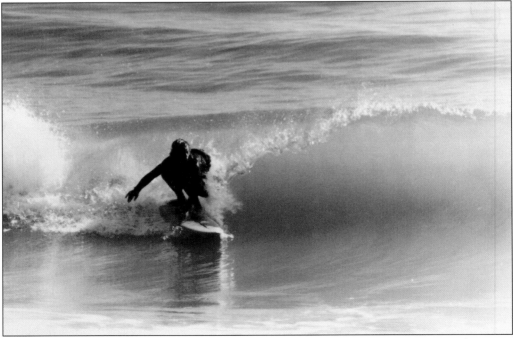

Pat Judd surfs a glassy early-1970s day at Bob Hall Pier. Judd won many surf contests in the 1970s, but surf trips with friends were what he really enjoyed. "Getting down to Costa Rica and Baja were great," he said. "I've been to New Zealand, Ireland, and also to Mexico a bunch of times. Surfed California in the early 1970s, and that was classic." (Courtesy of Pat Judd.)

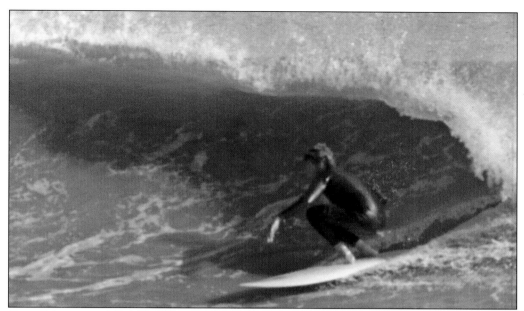

Steve Schuster surfs Bob Hall Pier in 1973. Schuster started surfing the Coastal Bend in 1964 and was still riding waves there in 2009. He joined the Kanaka Surf Club in 1967, his freshman year of high school. "One thing about early surf culture was the surf clubs—it was such an important part, what club you belonged to," Schuster recalled. (Photograph by Danny Jauer; courtesy of Jim Gayle.)

Glenn Francis hangs out on the beach in Port Aransas with friend Margaret White in August 1972. Francis was an accomplished surfer and also an artist who was responsible for a striking mural that covered one exterior wall of a Benjamin's surf shop in Flour Bluff. Francis shaped boards for Benjamin's and, later, for Joel Tudor of California. (Photograph courtesy of Margaret Ellison.)

Murray Judson takes aim with his camera in an early-1970s photograph. Judson was a surfer who also worked as a staff photographer with the *Corpus Christi Caller-Times*. Later, with his wife, Mary Henkel Judson, he became owner of the *Port Aransas South Jetty* newspaper. Few if any other photographers chronicled Coastal Bend beach life as exhaustively as Judson from the 1960s into the new millennium. (Photograph by Doug Kinsley.)

Larry Nichols surfs at Bob Hall Pier in an early-1970s session. A few years earlier, when he was a senior at Corpus Christi's Ray High School, he was allowed to check out of school each day during afternoon study hall to work on projects for his marine biology class. Usually he went surfing instead. "I'd bring back a shell or something," he said. (Photograph by Doug Kinsley.)

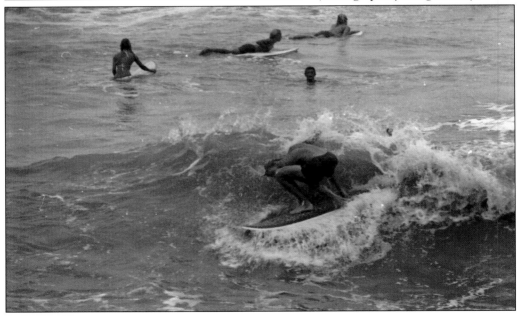

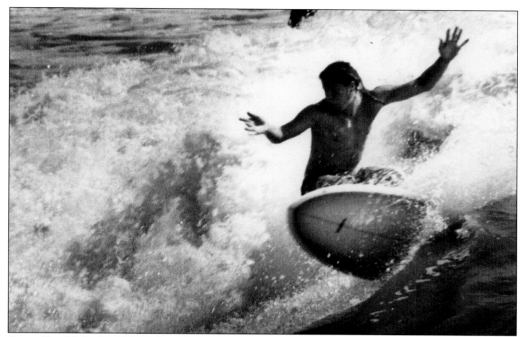

Brian Shackleford surfs North Padre on an early-1970s day. Shackleford was hard core, recalled old friend Johnny Cobb. "It would be mid-December, and the surf was, like, 10-foot, and the current was going 30 mph, and he would just . . . put on his wetsuit, and go out. There would be no one else out. It was just hellacious conditions, and yet he would do it." (Photograph by Doug Kinsley.)

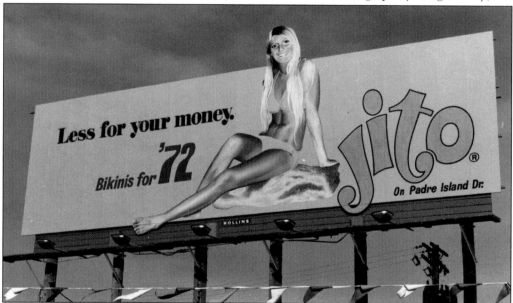

Cathie Cox of Corpus Christi models a bikini on a billboard on Padre Island in the early 1970s. Jito was a North Padre Island store. A Corpus Christi resident, Cox was a dedicated surfer of the 1960s and 1970s. "Those memories are probably some of the best memories of my life," Cox said in a 2008 interview. "There was something magical about that era." (Photograph by Doug Kinsley.)

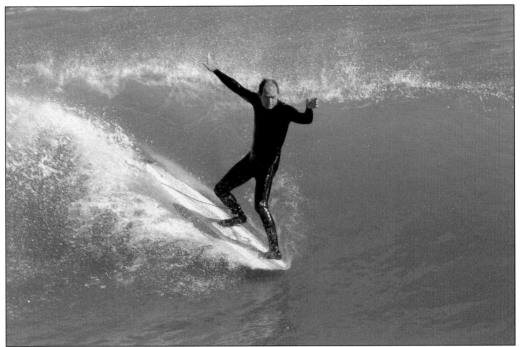

James Gill rides the nose at Bob Hall Pier in December 2006. Gill's first Coastal Bend surf experience was riding belly boards that he and friends cut from plywood and painted in 1962, when he was 11 years old. He started riding stand-up boards a year or two later. In later years, Gill surfed tanker-ship wakes in the Corpus Christi ship channel. (Photograph by Michael Boyd.)

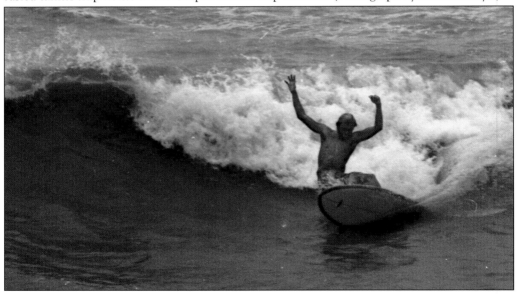

Keith Mabrey punches a hard bottom turn on a wave at Bob Hall Pier in an early-1970s photograph. "He was a red-hot goofy foot in the 1970s," recalled friend John Trice. "I always thought he surfed like [noted Australian surfer] Wayne Lynch, with big moves, both front and back side." (Photograph by Doug Kinsley.)

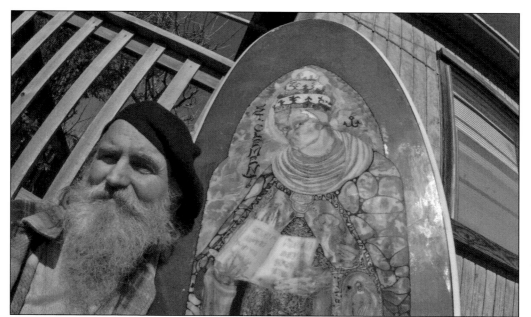

Artist Johnny Cobb poses with a painting of St. Clement that he created on his surfboard. "There's no patron saint for surfers, but he is patron saint for gondoliers and seamen and naval excursions, so I put him on the board as a kind of patron saint," Cobb said. Cobb was a member of the prestigious Jacob's Surfboards surf team in the 1970s. (Photograph by Dan Parker.)

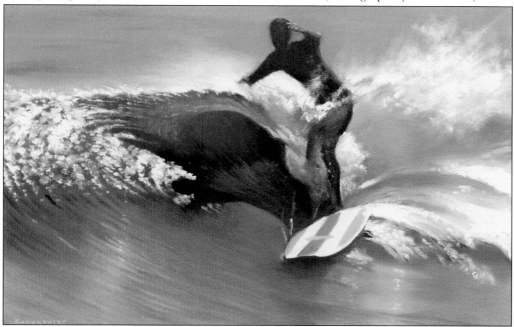

Titled "Creamy Caramel Center," this painting was created by Wade Koniakowsky, a surfer and artist who grew up in Corpus Christi. The painting was inspired by a G. Scott Ellwood photograph of longtime Corpus Christi surfer James Gill riding a wave at Horace Caldwell Pier in Port Aransas. (Courtesy of Wade Koniakowsky.)

Doug Loveless of Corpus Christi surfs at the Fish Pass in a late-1970s photograph. Loveless started surfing in Port Aransas in the early 1960s. He showed surf movies in auditoriums along the East Coast in the early 1970s and, later, in Corpus Christi. Loveless died at the age of 53 in 2006. (Photograph by Donna Self.)

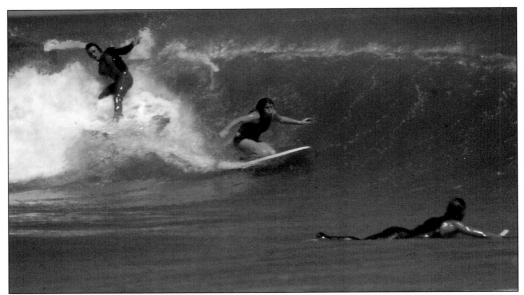

Donna Self rides a kneeboard at Mustang Island's Fish Pass in 1979. Self, of Corpus Christi, started surfing in the early 1960s and went on to win several Texas state titles in kneeboarding. She won national titles in the women's kneeboarding division at the U.S. Surfing Championships in the 1970s. (Courtesy of Donna Self.)

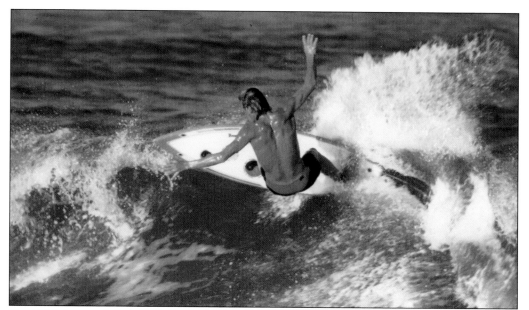

David Mokry surfs Bob Hall Pier in September 1985. Mokry learned from his brothers. Doug Mokry pushed David into his first wave, and Mark Mokry taught him to ride a skateboard. David went on to win surf contests, and he surfed in Hawaii for some years too, before moving back to Corpus Christi. (Photograph by David Burkhardt.)

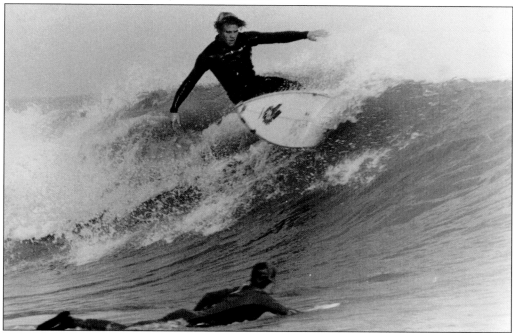

Doug Polansky of Corpus Christi redirects on a wave at the Fish Pass in a 1980s-era photograph. Polansky started surfing the Coastal Bend in 1974. He said the El Nino winter of 1982–1983 was one of the most memorable surf seasons ever, in his experience. "We had weeks and weeks of surf," Polansky recalled. "There were a lot of double-overhead days." (Photograph by David Burkhardt.)

Pictured here in 2006, David Burkhardt grew up in Taft and started surfing in 1964 in Port Aransas. He began shooting surf photographs in the late 1970s. His photographs were published in *Surfer*, *Surfing*, and *Swell* magazines. Burkhardt, whose Coastal Bend family roots go back to the early 1900s, worked for years as a farmer in San Patricio County. (Photograph by David Burkhardt.)

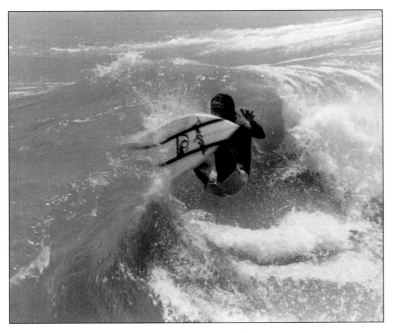

Kirk Pearson surfs at Bob Hall Pier on a day in the early 1980s. In addition to winning two Texas state championships, Pearson was the Amateur Athletic Union national men's division champ in 1981. He received some of the greatest exposure ever enjoyed by a Texas surfer when he was featured in photographs by fellow Texan Jimmy Metyko in *Surfer* magazine in 1983, 1984, and 1986. (Photograph by David Burkhardt.)

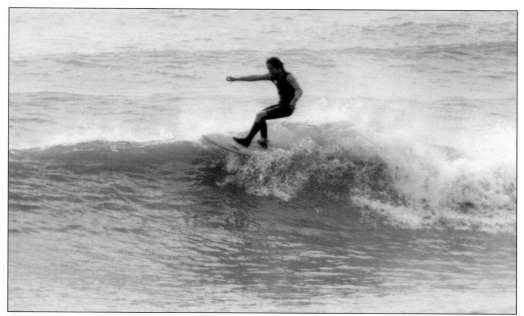

John Vosseller surfs in Port Aransas in the winter of 1980. Vosseller, with fellow Port Aransans Tiger Witt and Todd Olson, surfed on board-maker Gary Tinnerman's team, called the Death Squad. Each surfer had skulls and crossbones on his board. Vosseller took first place in the amateur division and fourth in the pro division at the Sundek Texas Classic contest on North Padre Island in 1984. (Courtesy of John Vosseller.)

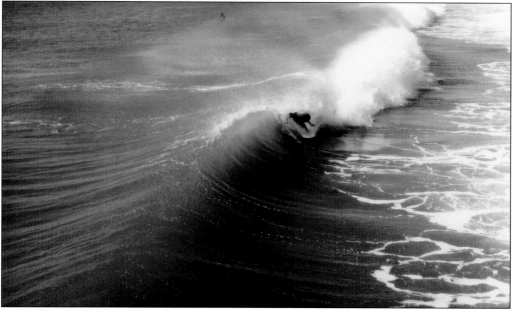

Randy Rees is tubed at Bob Hall Pier one day in the early 1980s. Surfing in the master's division, Rees took state championships with the most points scored over the course of competitive years ending in 1987, 1988, and 1989. Rees moved to Hawaii in 1990 and became a fixture at legendary North Shore spots like Sunset Beach. (Photograph by David Burkhardt.)

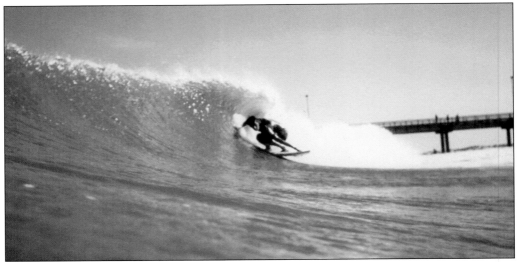

Lindsey Winston tucks under a pitching lip near Bob Hall Pier in the mid-1980s. Winston was one of the core members of Corpus Christi's Orangewood Surf Club. Other core members included James Neal, Pat Hinch, and Mike Wilson. The club threw surf-stomp parties that attracted hundreds of people who danced to the music of local band Aloha Dave and the Tourists. (Courtesy of Lindsey Winston.)

Members of Corpus Christi's Orangewood Surf Club ride in a car they called "the Roach Coach" about 1980. Using his father's Exxon credit card, a young club member bought the car for $100 at South Padre Island and then drove it back to Corpus Christi. The hood flew off the dilapidated vehicle on the drive back, nearly smashing into a Mercedes Benz. (Courtesy of Lindsey Winston.)

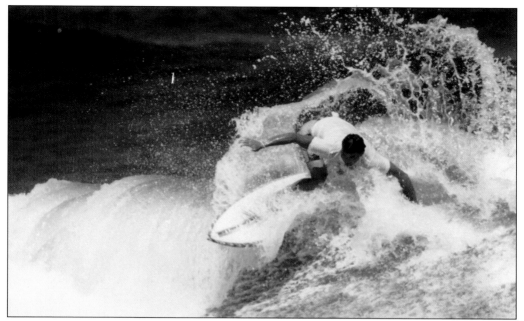

Kevin Jones shreds a wave at Bob Hall Pier in a 1980s photograph. Jones scored big in surf contests in the 1980s. He surfed on Corpus Christi's Island Surf N Sunwear surf shop team. "Kevin perfectly bridged two eras of surf style," said John Trice, the shop owner. "Very smooth, but also very powerful. Beautiful to watch." (Photograph by David Burkhardt.)

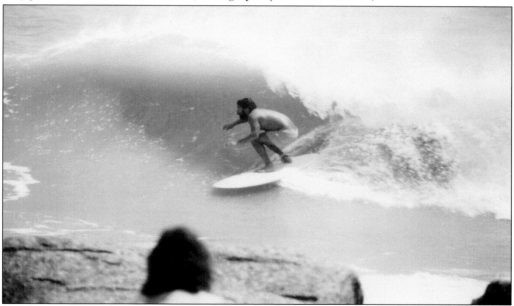

Rafael "Ralph" de Pena rides a wave at the Fish Pass in a 1980s photograph. The grandson of Rafael Leonidas Trujillo Molina, a former Dominican Republic dictator, de Pena grew up in Corpus Christi and started surfing in 1966. De Pena later worked as a commercial diver and an underwater demolition expert, surfing the entire Pacific coast, from Washington to Chile. (Photograph by David Burkhardt.)

Sue Sorrell of Corpus Christi almost single-handedly produced the longest-lived series of surf magazines ever to come out of the Corpus Christi area and possibly the entire state. Published under various titles including *Corpus Christi Breaks* and *Surfabout*, the magazines were produced from 1982 to 1993. Sue did most of the writing, nearly all of the photography, and every bit of the layout. (Courtesy of Sue Sorrell.)

Michael Boyd of Corpus Christi rides a clean wave at Bob Hall Pier in March 1989. In surf contests from 1979 to 1985, Boyd twice achieved top state rankings. His photography has been published in surf magazines and at least one book. Boyd is the former brother-in-law of Randy Rarick, a Hawaii resident known as one of the world's top pro surf contest organizers. (Photograph by David Burkhardt.)

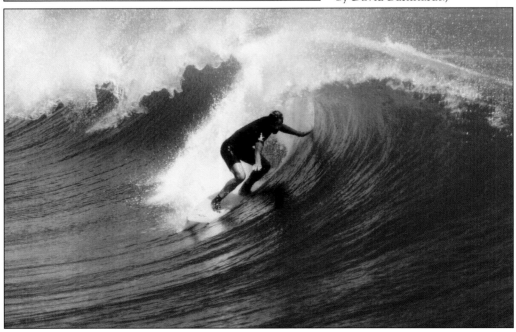

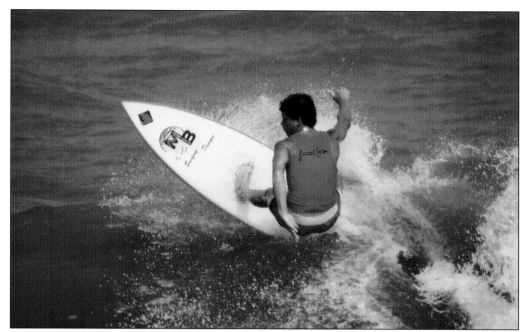

Richard Netek tears the top off a wave on a mid-1980s day at Bob Hall Pier. Netek was a hot enough surfer in the 1980s to be sponsored by Gotcha Sportswear, Local Motion surfboards, and Island Surf N Sunwear. He surfed alongside famous Gotcha surfers, including Australia's Cheyne Horan and Hawaii's Dane Kealoha. (Photograph by David Burkhardt.)

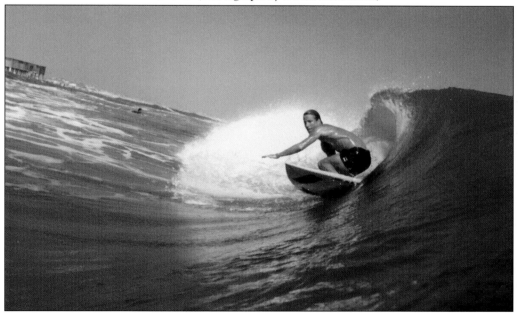

Kenny O'Connor of Corpus Christi rides a wave near Bob Hall Pier in a photograph shot from the water in 1987 by David Burkhardt. One of the most talented surfers ever to emerge from the Coastal Bend, O'Connor died at the age of 29 in a surfing accident in big waves at South Padre Island in October 1992. (Photograph by David Burkhardt.)

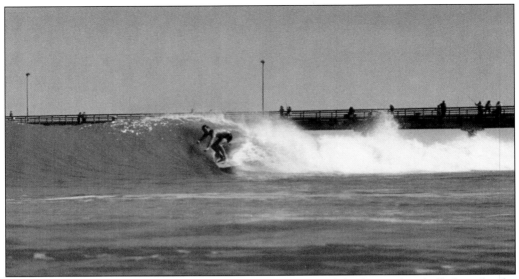

Ty Cobb is slotted at Bob Hall Pier in 1984. Cobb, a cousin of the famous baseball player by the same name, started surfing the Coastal Bend in 1968. He ran a surfboard rental stand at Million Dollars for two summers during the longboard era. Cobb went on to surf all over the world and raised a son, Ryan, who became a strong competition surfer. (Photograph by Kerry Kirksmith.)

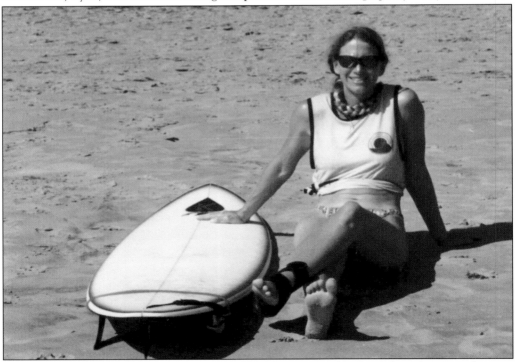

Growing up in Corpus Christi, Sue Comparato Hopkins started surfing when she was eight years old, sometimes riding tandem on a longboard with her brother, Jeff, a lifeguard on North Padre Island. Later she took two state championships and a second place in a national surf contest in the 1980s and 1990s. (Photograph by Donna Self; courtesy of Joy Zamora.)

Jay Bennett surfs near Horace Caldwell Pier in 2008. Bennett, who grew up in Port Aransas, was ranked first in the state in his division at the end of each competitive season from 1983 to 1987 and was a member of the U.S. Surf Team in the mid-1980s with future world champion Kelly Slater of Florida. Slater mentioned Bennett in his book *Pipe Dreams*. (Photograph by Dan Parker.)

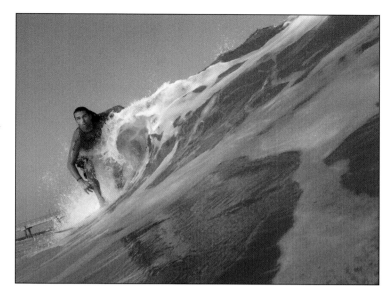

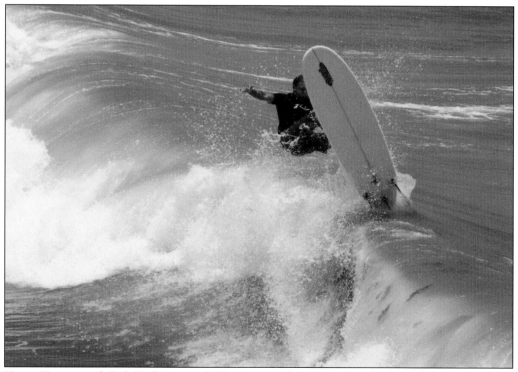

Kevin Tansey surfs Bob Hall Pier in 2002. Tansey, who grew up in Corpus Christi, is among a relative few Coastal Bend surfers who have scored national championships in surf contests. He took first place in the masters longboard division at the U.S. Surfing Championships in 1995. He was selected for the National Scholastic Surfing Association's national team in 1982 and 1983. (Photograph by Michael Boyd.)

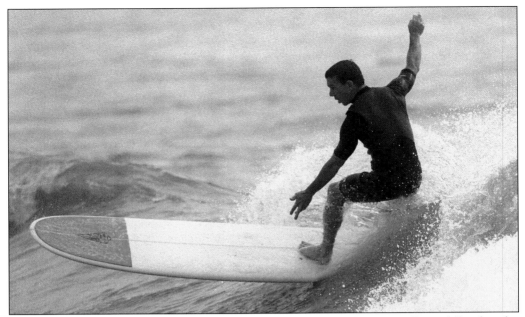

Above, John Olvey surfs at Mustang Island State Park in 1998. A veteran Coastal Bend surfer, Olvey won first place in the senior longboard competition at the U.S. Surfing Championships at South Padre Island in 1995 and in California in 1998. He won a national championship for kneeboarding in 1995. Olvey also served as competition director for the Texas Gulf Surfing Association and as treasurer for the U.S. Surfing Federation. An artist, Olvey creates paintings with surfing as a frequent theme. Below, Olvey mixes paint for a mural at the Port A. Surf Company surf shop in 2007. "I just want to show the sheer joy it is to be in the water," he said. (Above, photograph by David Adame, courtesy of the *Corpus Christi Caller-Times*; below, photograph by Michelle Christenson, courtesy of the *Corpus Christi Caller-Times*.)

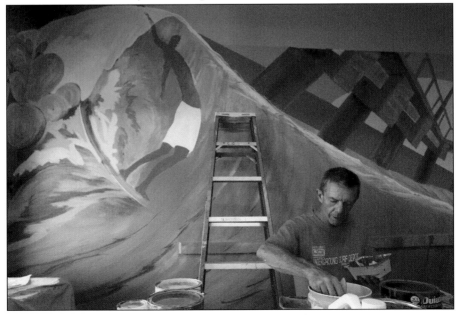

Rita Crouch took first place in the girls' division in the U.S. Surfing Championships in 1983, the year she graduated from Corpus Christi's King High School. In 1991, Crouch took first place in the women's division of the U.S. Surfing Championships in Port Aransas. (Photograph by Shaw "Shaw Dog" Schofield.)

Chris Guzman finds a hollow wave at Bob Hall Pier in 2003. Over the years, Guzman won state championships in the boys, junior men's, men's, and masters divisions. That included 20 first-place finishes. His surfing experience took him from Texas to California, Mexico, the East Coast, and Hawaii. (Photograph by Michael Boyd.)

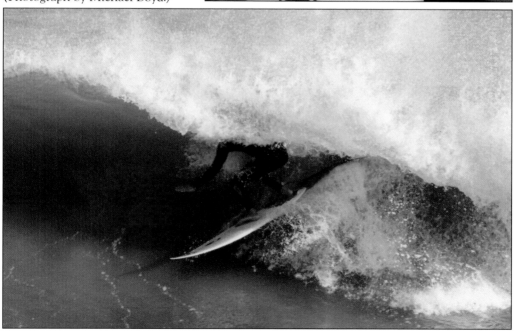

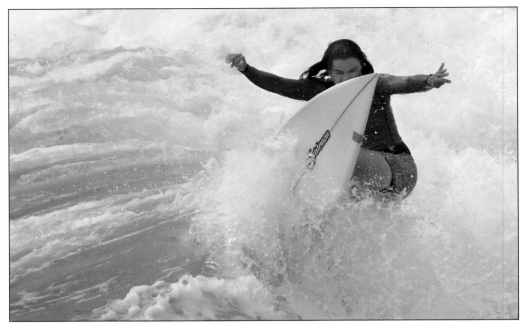

Julie Polansky of Corpus Christi bashes the lip of a wave at Bob Hall Pier in 2008. Among Polansky's many competitive highlights was taking second place in the women's division of the U.S. Surfing Championships (USSC) in Port Aransas in 1991 and first place in the senior women's division at the USSC in Oceanside, California, in 1999. (Courtesy of G. Scott Imaging.)

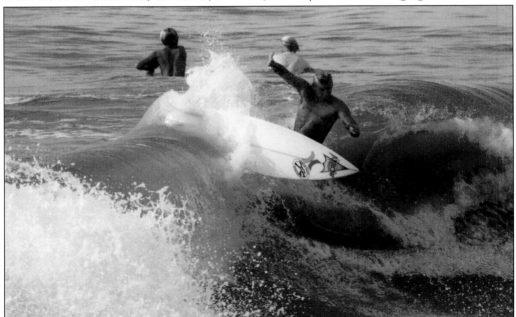

Corpus Christi's J. B. Englerth surfs Bob Hall Pier in 2002. Englerth spent his high school years living in Corpus Christi and honing his surfing skills until leaving the state and competing for four years against top surfers from all over the world in the Professional Surfing Tour of America, a circuit of contests around the United States and other countries. (Photograph by Michael Boyd.)

Jon Steele carries camera gear while shooting surf photographs at Bob Hall Pier in April 2003. As of late 2009, Steele was the only person ever to emerge from the Coastal Bend as a full-time professional surf photographer. From 1999 to 2009, Steele's work was published in the *New York Times* and other publications, including *Surfer* magazine and *Surfer's Journal*. (Photograph by Michelle Christenson; courtesy of the *Corpus Christi Caller-Times*.)

Ryan Cagle of Corpus Christi surfs Bob Hall Pier in 1998. Cagle earned several state championships in the 1990s and took second place in the menehunes division of the U.S. Surfing Federation championships at Sebastian Inlet, Florida, in 1994. He has developed into an accomplished big-wave surfer since then. (Photograph by Jason LeBlanc.)

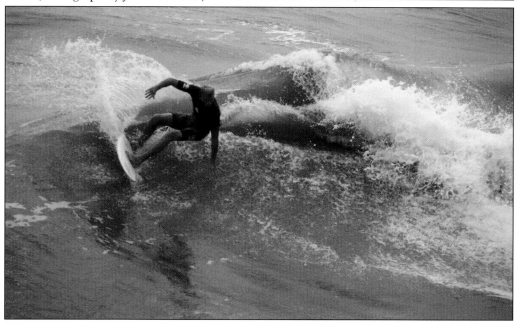

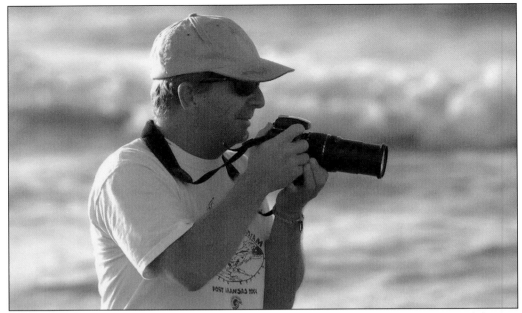

G. Scott Ellwood shoots photographs at a surf contest in Port Aransas in 2008. Ellwood, known simply as G. Scott, is a surfer, but he is most recognized for his photography. For several years beginning in 2003, no one more exhaustively chronicled surfing in Texas than Ellwood, of Corpus Christi. His photographs are particularly known for their crystal clarity and high action. (Photograph by Lyndon Thomason.)

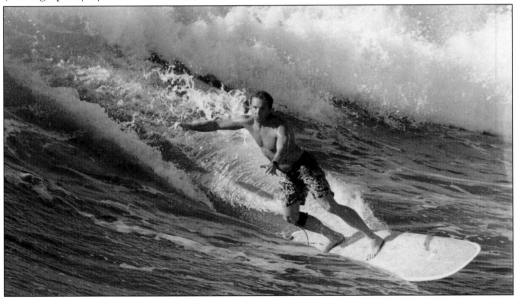

Brad Lomax surfs in Port Aransas around 2001. Lomax grew up in San Antonio and began surfing the Coastal Bend in 1967. He later moved to Corpus Christi and, beginning in 1983, established a cluster of successful businesses in the city's downtown, including the Executive Surf Club, drawing live music acts and surfers from all over. Lomax also founded the Texas Surf Museum. (Courtesy of Brad Lomax.)

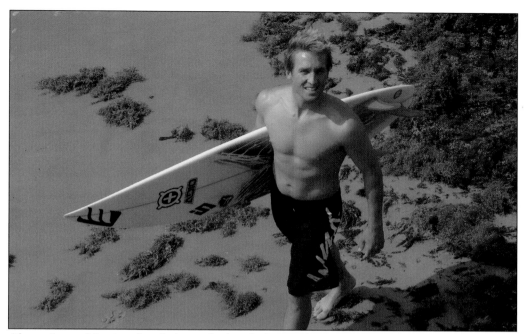

Above, Layne Harrison heads down the beach during the Da Hui surf contest at Bob Hall Pier in 2005. One of the most successful competition surfers ever to emerge from the Coastal Bend, Harrison took first place in several pro-am surf contests in California between 2002 and 2006. He was ranked in second place, overall, in the Professional Surfing Tour of America in 2003. He has been seen on ESPN and in numerous surf magazines. Harrison's travels as a surfer have taken him to such far-flung locations as the Philippines, South Africa, and El Salvador. Below, Harrison charges a wave at the Fish Pass on Mustang Island in 1991. (Above, courtesy of G. Scott Imaging; below, courtesy of MRG 3000.)

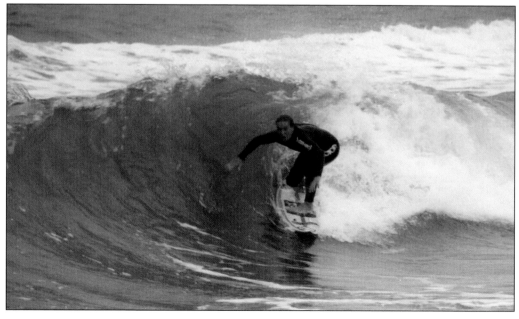

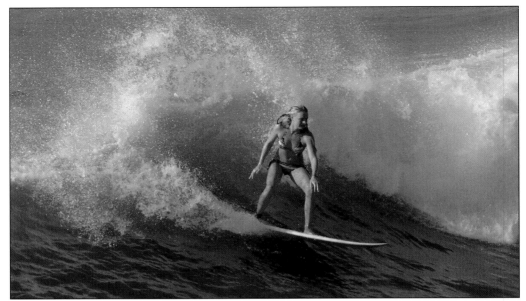

Brittany Tupaj rides a wave at Horace Caldwell Pier in Port Aransas in 2007. Tupaj, who grew up in Port Aransas, took first place for total points scored in contests throughout the 2008 season in the shortboard and longboard divisions. She also worked for the Texas Surf Camps in Port Aransas and taught private surf lessons. (Courtesy of G. Scott Imaging.)

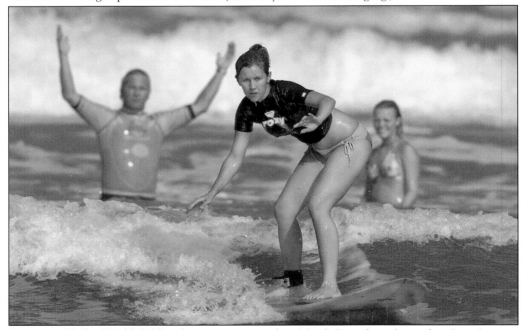

Instructor Phillip "Puddy" Albright encourages student Mindy Beverly as she surfs in Port Aransas in May 2005. Albright started surfing in 1964, served as manager of Corpus Christi's Down South Surf Shop in the late 1960s, and later worked in various roles for Surfer Publishing Group. He taught a surfing class at Texas A&M University-Corpus Christi from 2005 to 2007. (Photograph by George Tuley; courtesy of *the Corpus Christi Caller-Times*.)

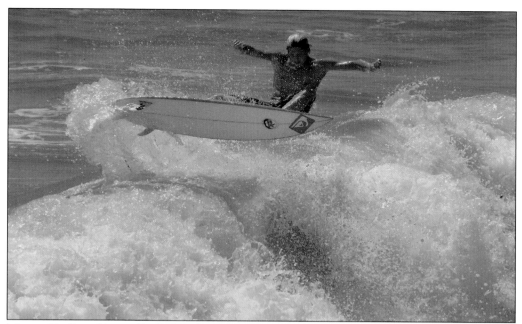

Morgan Faulkner blasts off at Bob Hall Pier August 24, 2007. Faulkner, who grew up in Port Aransas, has been considered one of the best competitive surfers ever to emerge from Texas. Among his biggest wins are a first place in the pro longboard division at the East Coast Surfing Championships at Virginia Beach, and first place in the junior longboard division at the U.S. Surfing Federation Championships at Oceanside, California. In 2004, Faulkner began operating Texas Surf Camp, providing lessons for children in Port Aransas. Below, Texas Surf Camp instructor Brittany Tupaj helps a young student carry a board into the surf. (Above, courtesy of G. Scott Imaging; below, photograph by Michelle Christenson, courtesy of the *Corpus Christi Caller-Times*.)

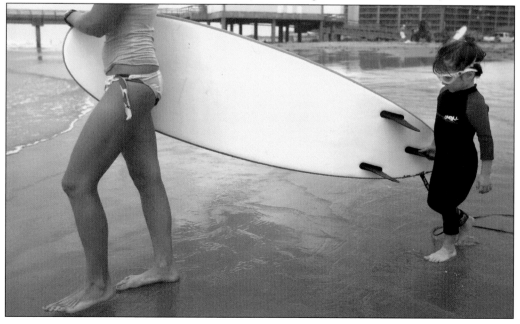

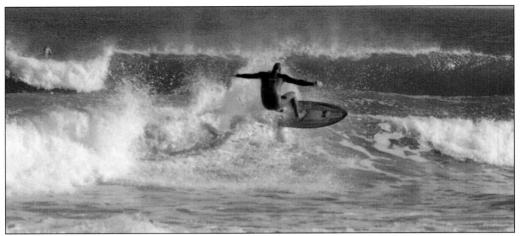

Allen Lassiter hits the lip on a Packery Channel wave during the winter of 2006–2007. Lassiter grew up in Corpus Christi and went on to become a garage surfboard shaper who produced at least 250 boards over the years. His boards first bore the brand name of Pico Alto and later were named Surf This. (Photograph by Michael Boyd.)

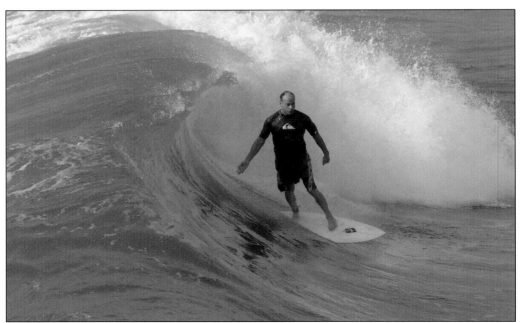

David Holloway surfs at Bob Hall Pier in April 2008. Holloway, who started surfing in 1969 with his two older brothers, said he was more of a soul surfer than a contest surfer. "I have shared waves and thoughts with many former, current, and future surf legends through the years, and will continue being drawn to the ocean until the end," he said. (Courtesy of G. Scott Imaging.)

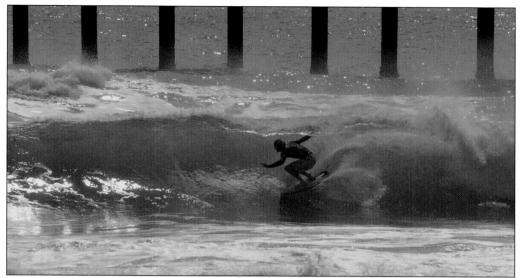

Above, Jake Jalufka ducks the lip of a wave breaking at Bob Hall Pier on October 17, 2008. At right, Jake's brother, Justin Jalufka, shreds a North Padre Island wave generated by Tropical Storm Erin in August 2007. The Jalufka brothers were among the hottest Corpus Christi surfers of the new millennium. "Being identical twins, we push each other and push each other," Justin said in an interview. "Both of them are really good," said Cliff Schlabach, a longtime Texas Gulf Surfing Association judge. "On any given day, they can take top honors. Two of our best competition surfers. They rip in big waves in Mexico, too." (Above, courtesy of G. Scott Imaging; right, photograph by Todd Yates, courtesy of the *Corpus Christi Caller-Times*.)

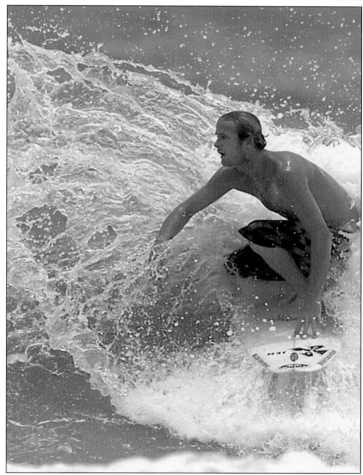

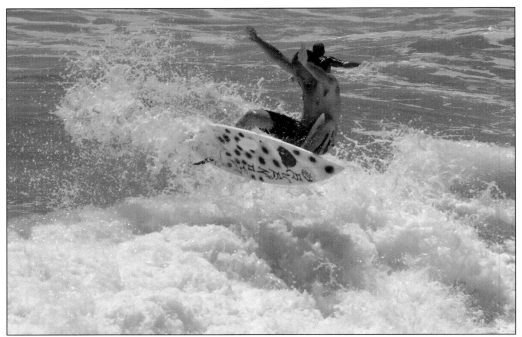

Greg Cheek of Corpus Christi gets some air while simultaneously displaying some of his artwork in May 2006 at Bob Hall Pier. Over the years, Cheek has used his surfboards as a canvas, creating artwork with markers and spray paint. Cheek was the men's division state champion by total points accumulated in the 2005–2006 season. (Courtesy of G. Scott Imaging.)

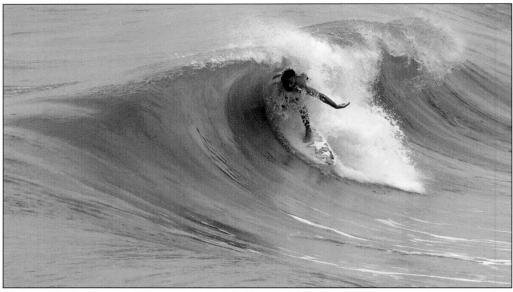

Nathan Floyd of Corpus Christi surfs Bob Hall Pier in 2007. Floyd took second place in the men's longboard division of the 2008 Surfing America championships at Huntington Beach, California. A film student, Floyd also did the editing on three small surf flicks that he and friends created in 2008 and 2009. The films played to crowds in Corpus Christi. (Courtesy of G. Scott Imaging.)

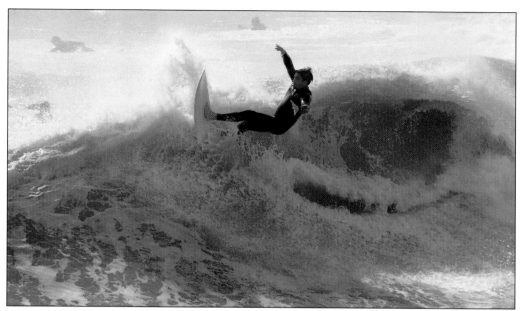

Warren Woolridge flies high at Bob Hall Pier February 11, 2009. Woolridge started surfing in 1969 and won the men's division of the Texas State Surfing Championships in 1979. He has surfed all over the world, but it was a photograph of him riding a hurricane-generated wave at North Padre Island that appeared in the February 2003 issue of the internationally distributed *Surfer* magazine (Courtesy of G. Scott Imaging.)

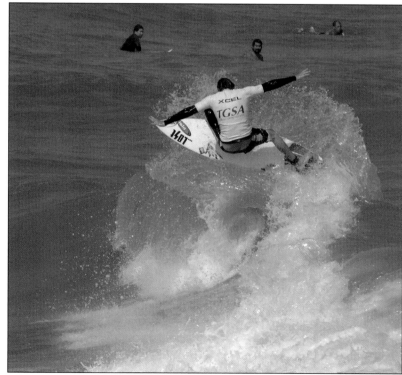

Wes Beck Jr. gets some air during the Texas Gulf Surfing Association's Corpus Christi Open at Bob Hall Pier on March 30, 2008. Beck and his father, Wes Beck Sr., long have been fixtures on the Coastal Bend surf scene, often competing in surf contests over the years. (Courtesy of G. Scott Imaging.)

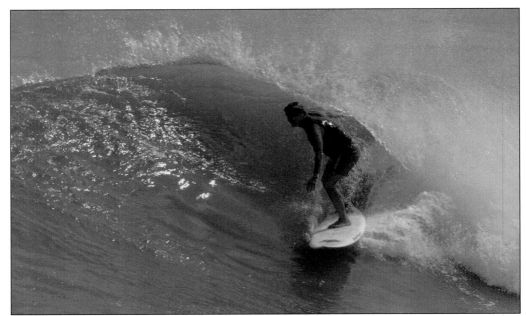

John Trice emerges from a tube at Bob Hall Pier in 2004. Trice started surfing in the mid-1960s. In those early days, he and his brother, Joe, used to hitchhike from their Corpus Christi home on the mainland to North Padre Island to go surfing. They shared a 9-foot, 6-inch Weber board on those trips, taking turns in the surf. (Courtesy of G. Scott Imaging.)

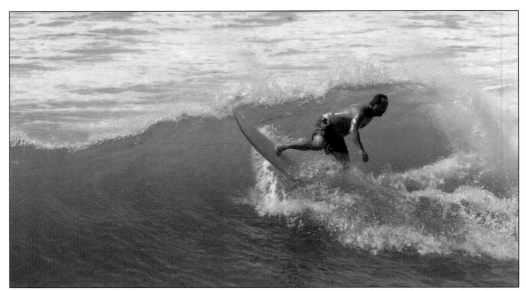

Paul Balcom of Port Aransas surfs Horace Caldwell Pier in 2008. Balcom, who started surfing in Port Aransas in the mid-1970s, was known to some as "Polar Bear Paul" for his habit of surfing without a wetsuit in winter surf. (Photograph by Michelle Christenson; courtesy of the *Corpus Christi Caller-Times*.)

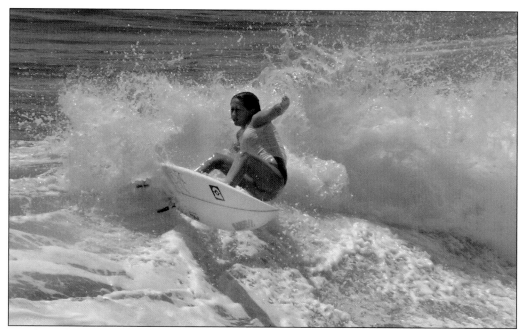

Nicole Dodson of Corpus Christi slashes a wave at Bob Hall Pier on July 27, 2007. Besides winning multiple state championships in the new millennium, Dodson was featured with her sister, Danielle, and Houston's Molly Ware in a small documentary surf film, *Tex 2 Mex Chix*, made in 2005 and 2006. (Courtesy of G. Scott Imaging.)

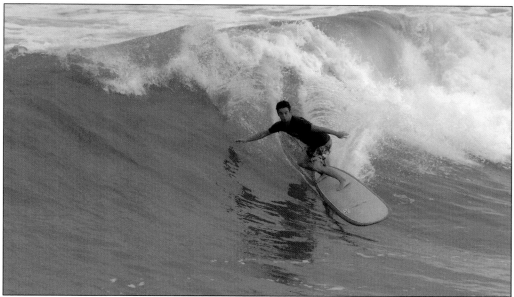

Cayce Watson of Corpus Christi surfs Bob Hall Pier on October 9, 2004. Watson, the 2005 men's longboard Texas state champion, began serving in a special U.S. Army reconnaissance platoon in Iraq in 2008. After he narrowly missed an encounter with an enemy booby trap, he went on leave and took a surf trip to Mexico with his father, Jeff, "to celebrate his life," Jeff said. (Courtesy of G. Scott Imaging.)

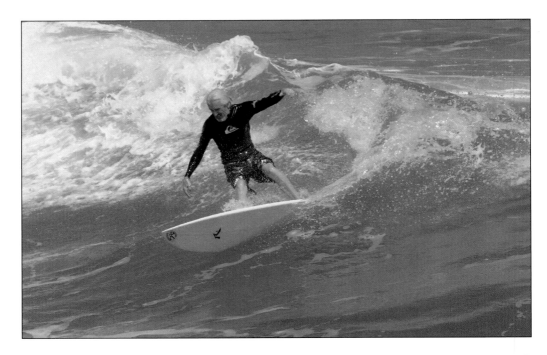

Above, Brad Steph cuts back at Bob Hall Pier on March 27, 2009. Surfing Texas since 1964, Steph won in the legends division of the Texas State Surfing Championships and took fourth place in a national competition in 2007. Steph has passed along the stoke to the next generation, putting his toddler son, Micah, on a surfboard and pushing him into small waves in the 1980s. Micah grew up to be a strong surfer and artist who worked with friend and fellow Corpus Christi surfer Nathan Floyd to craft surf movies, which they premiered at art shows they organized. Below, Micah drops into a nice wave at Bob Hall Pier on April 25, 2007. (Photographs courtesy of G. Scott Imaging.)

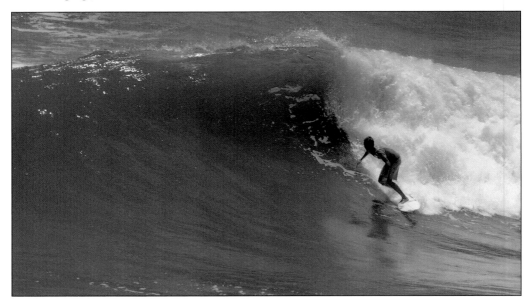

Three

SURF SHOPS AND BOARD MAKERS

Surf shops and surfboard makers provide the stock that sustains surfers, but the business enterprises are important to wave riders for other reasons, too. Surf shops are like community centers for surfers, where they can chat with each other about recent surf adventures while surrounded by products that have become ingrained in surf culture: surf trunks, surf magazines, surf videos, and, of course, rows and rows of gleaming new surfboards. There is nothing quite like the aroma of a surf shop, a heady mixture that combines the new-car smell of neoprene wetsuits with the fruity fragrance of scented surf wax.

In the Coastal Bend, surfboards first became available to the general public through beach rental stands. A North Padre Island operation established in 1962 by Cecil Laws and his son, Larry, was apparently the first. Surf shops on city streets sprouted within the next few years in Corpus Christi and Port Aransas.

The first board makers worked out of their home garages. Later they established themselves in commercial facilities. One of the Coastal Bend's first board makers, Jim Copeland, began hand-shaping boards in 1964, relying on instinct and phone calls to a California shaper for advice. Copeland soon became a competent shaper. An employee, George Loe, became an especially good shaper after Copeland sent him to California for training.

While many Coastal Bend surf shops and board makers are pictured in this book, others are not, partly because no photographs of the businesses could be located. Those surf shops include Johnny Roberts' Beachway surf shop and Danny Holt Surf Shop of Port Aransas and Murtoff's Hobie Shop, Covered Up Surf and Skate, Hole in the Wall, and Jay's Surf Shop, all of Corpus Christi. Surfboard makers not pictured include Lund Surfboards, Pure Design, and East of Hawaii, all of which operated in Port Aransas; TVS surfboards, made by Tom Scott, of Corpus Christi; and The Texan, a brand made by teen-agers John White and Jim Dinn, in Dinn's garage at 216 Indiana Avenue, in Corpus Christi, during the 1960s. In addition, in the 1960s, Terry Baggett rented boards on North Padre Island, and Johnny Peel operated John's Surf Shop out of his parents' house at 522 Driftwood Place in Corpus Christi.

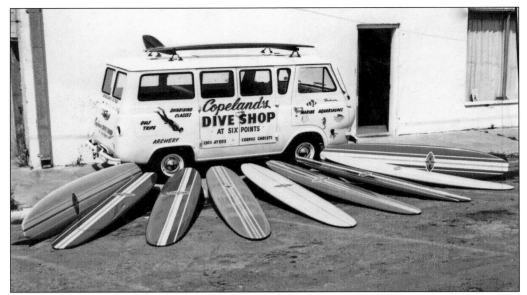

An array of boards lies next to a Copeland's Dive Shop van in Corpus Christi. Jim Copeland founded his dive shop in 1958 and began ordering surfboards and selling them in his shop in the early 1960s. Copeland's also made its own boards, but the operation ceased after Hurricane Celia destroyed the manufacturing facility in 1970. (Courtesy of Jim Copeland.)

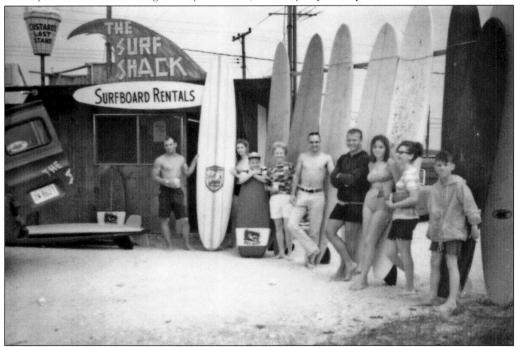

The Surf Shack, seen here in the mid-1960s near the intersection of Beach and Station Streets in Port Aransas, was not Marvin Harper's first surf shop. He first sold surfboards at Alameda-Airline Sporting Goods, which he opened in late 1963 and sold in 1971. He opened the Surf Shack in 1964. (Courtesy of Pat Magee.)

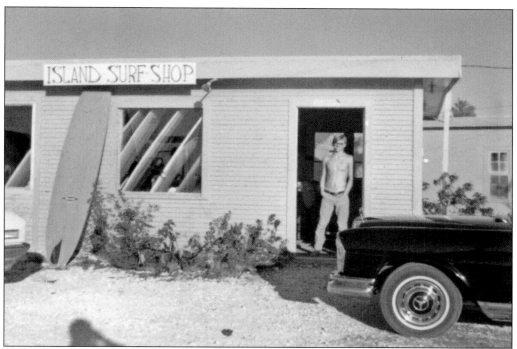

George Hawn Jr. hangs out at his business, Island Surf Shop, in 1966. Established in spring 1966, the shop was in a building that formerly served as a small general store on the northeast corner of the intersection of Beach and Station Streets in Port Aransas. The Hawns sold the property in 1969, and Pat Magee then established a new surf shop in the location. (Courtesy of George Hawn Jr.)

Glenn Morisse, (standing) and Jody Weisel (seated) hang out at Island Surf Shop at Beach and Station Streets in Port Aransas about 1966. Weisel was the main artist who created the psychedelic mural on the wall of the building, which at one time was a general store. (Courtesy of George Hawn Jr.)

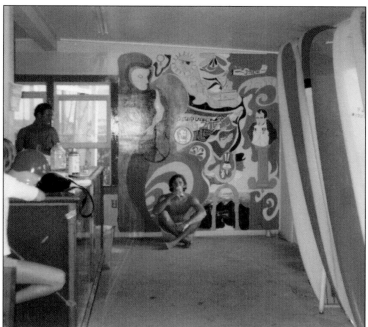

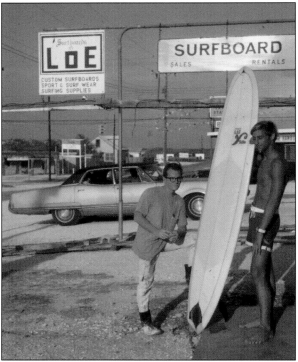

George Loe (left) and his brother, David, work in their Beach Street shop in Port Aransas about 1966. The Loes also had a board-making facility in the 1600 block of Eighteenth Street in Corpus Christi and a retail shop, Surfboards by Loe, at Weber Shopping Center. The Loes produced an estimated 3,000 boards before Hurricane Celia wiped out their businesses in 1970. (Courtesy of Pat Magee.)

George Loe, left, and Pat Magee hang out at the Loe board shop on Beach Street in Port Aransas about 1967. Magee and Pat Harral shaped boards for Loe. In the tall building in the background, just under the traffic light, Dockside General Store and Emporium opened later, offering surf supplies and other merchandise. Dockside, owned by Jerry and Cora Chisholm, burned in 1982. (Courtesy of Johnny Roberts.)

Jane Bryson and an unidentified boy pose for a photograph at the surfboard rental stand she operated with Pat Magee in 1968. Bryson, who grew up in Corpus Christi, was one of the earliest state champions in Texas surfing, winning the women's state title in 1964. (Courtesy of Jane Bryson.)

Pat Magee (left) and partner Mike Lee stand near the Port Aransas beach stand they operated in the mid-1960s. It was Magee's first taste of the surfing-oriented retail world, and with his wife, Mary Lynn Magee, he established surf shops throughout Texas in later years. "I found that I enjoyed making money and doing what we all wanted to do—go surfing and be out at the beach," Magee recalled. (Courtesy of Pat Magee.)

Pat Magee Surf Shop opened in Port Aransas in 1969, eventually expanding to Austin, San Marcos, San Antonio, Dallas, College Station, and North Padre Island. Magee closed his last shop, in Port Aransas, in 2005. Due largely to his shop's popularity over the years, Magee stands as possibly the most recognizable name in Coastal Bend surfing. (Courtesy of Pat Magee.)

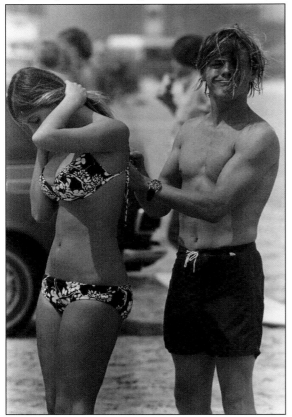

Larry Boeck ties up a bikini for a friend on the beach in Port Aransas in the early 1970s. Boeck operated Larry Boeck Surf Shop in the early 1970s at various Corpus Christi locations and produced Larry Boeck Surfboards, most of them shaped by Danny Jauer. Boeck dominated many Texas surf contests throughout the 1970s. Boeck's brothers, Phil, Jack, and Mikey, also surfed. (Photograph by Murray Judson.)

Down South Surf Shop stands at Corpus Christi's Salem Shopping Center in the 4300 block of South Alameda Street. Tony Mierzwa established the shop in 1965 after working in the early 1960s for Cecil and Larry Laws, renting surfboards on the beach on North Padre Island. Down South closed in 1978. (Courtesy of Pat Magee.)

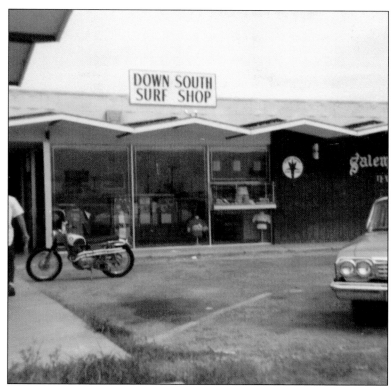

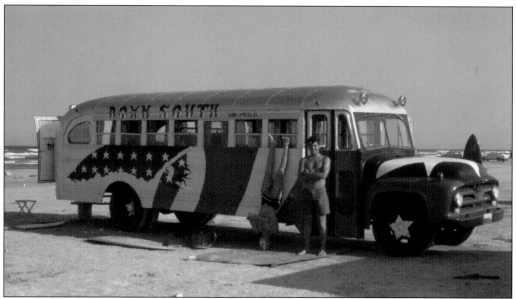

Steve Stephenson, left, and Miles Compton hang out with the Magic Bus in Port Aransas in 1970. Down South Surf Shop of Corpus Christi rented surfboards out of the bus on the beach in Port Aransas. Stephenson did the artwork on the bus. Compton operated the rental enterprise. The bus was named after The Who song "Magic Bus." (Courtesy of Tony Mierzwa/ Down South Collection.)

Larry Haas shows some of the surfboards in his Laguna Shores Surf Shop, located at 4314 South Staples Street in Corpus Christi, in 1967. Larry later became owner of Tire and Lube Express in Corpus Christi. Dennis Haas, Larry's brother and partner in the surf shop business, later became an industrial designer in Corpus Christi. (Courtesy of Larry Haas.)

Roger Barrus and Larry Haas are shown here at a Laguna Shores surf shop board rental stand in 1967. Haas established a beach rental stand in 1965 and the following year founded a surf shop, Laguna Shores, at 4314 South Staples Street in Corpus Christi. His brother, Dennis, was a partner and ran the beach concessions while Larry ran the store. They closed the store in 1968 and ended the beach concession in 1974. (Photograph by Mary Lou Williams.)

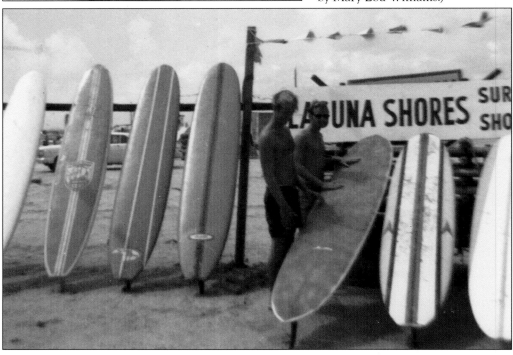

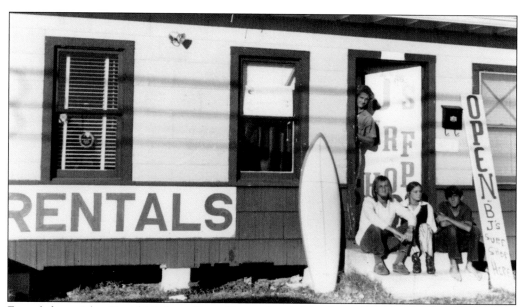

From left to right, David Hudson, Doug Foster, Sarah Moody, and Robert Rudine hang out in front of B. J.'s Surf Shop in Corpus Christi in an early-1970s photograph. The first B. J.'s Surf Shop opened in Houston in the early 1960s, and outlets sprouted up and down the Texas coast after that. (Photograph by Doug Kinsley.)

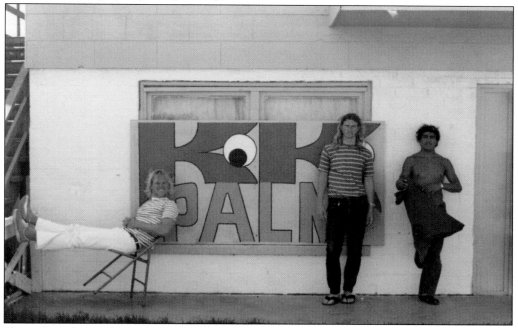

Shown here from left to right are Charlie Elliot and Don Reese, both of Corpus Christi, and Lalo Tiznado, of San Blas, Mexico, hanging out at Koko Palm Surf Environment in Corpus Christi. The surf shop first occupied 4342 South Alameda Street, and then moved to 1225 Airline Road. Partners Jim Gayle and Don Reese owned Koko Palm, which operated in the early 1970s. (Courtesy of Jim Gayle.)

At his mother's home in Corpus Christi, Mark Ulrich poses in 1971 with just the second board he ever made. Ulrich established the Hosanna label in 1973, building his boards mainly out of a shaping bay on Rodd Field Road in Corpus Christi. He estimates that he had made about 2,000 boards by the time he hung up his planer in the mid-1990s. (Courtesy of Mark Ulrich.)

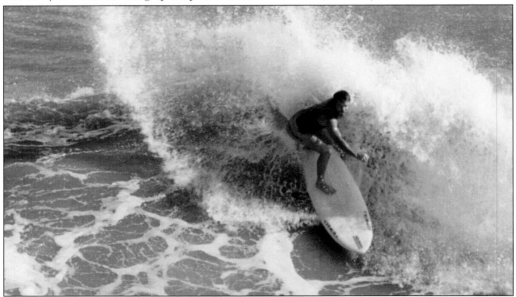

Board maker Mark Ulrich throws a huge rooster tail on a wave at Bob Hall Pier in 1983. Ulrich, who had Bible verses posted on the walls of his shaping room, preached to surfers who gathered to watch him shape surfboards. It annoyed some and inspired others. His outspokenness about his Christian faith, he once said, "caused me more trouble and joy than anything." (Photograph by Sue Sorrell.)

78

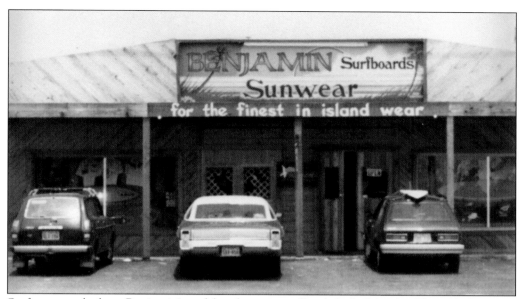

Surfers are parked at a Benjamin's surf shop location on South Padre Island in Flour Bluff in 1979. Over the years, Benjamin's shops also were located at Padre Staples Mall and 1233 Airline Road in Corpus Christi. Benjamin surf teams took many contest honors from the late 1970s through the late 1980s. (Photograph courtesy of Ben Liska.)

Benjamin Liska holds one of his boards in 1976, the first year he began producing boards commercially. After that, Benjamin boards were manufactured everywhere from Corpus Christi to California to China. In Corpus Christi, Benjamin shapers included Danny Jauer, Glenn Francis, and Liska himself. Benjamin's Corpus Christi surf shops have long been successful commercial ventures. (Courtesy of Benjamin Liska.)

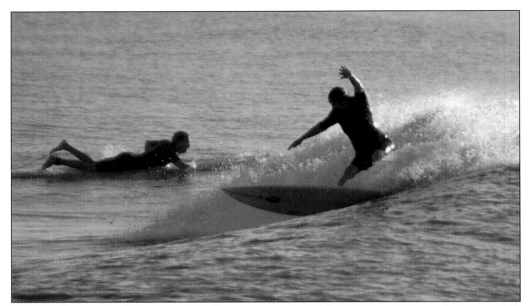

Tippy Kelley cuts back hard on a Fish Pass wave on April 18, 2007. In addition to being a stand-out wave rider, Kelley has represented her sport well in other ways. She has been a beach rights advocate for decades, and her Dockside surf teams sponsored more than 100 team riders over the years, taking seven first-place Texas state surf team titles. (Photograph by Michael Boyd.)

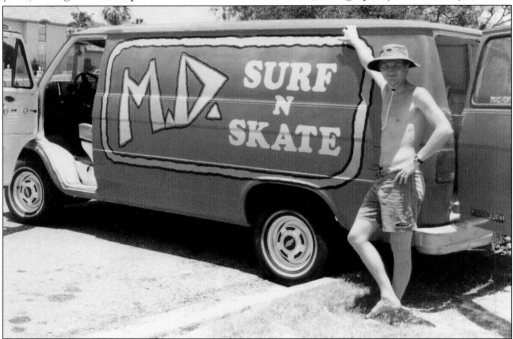

Mark Dulaney stands with his shop's van about 1989. Dulaney established MD Surf and Skate in 1982 at 4016 Weber Road. MD had surf, skate, and windsurfing teams. In promotional ventures, the shop brought in world-famous skaters like Tony Hawk and big-time surfers including Ken Bradshaw. Dulaney sold the shop in 2001, and it closed in 2006. (Courtesy of Mike and Sue Dulaney.)

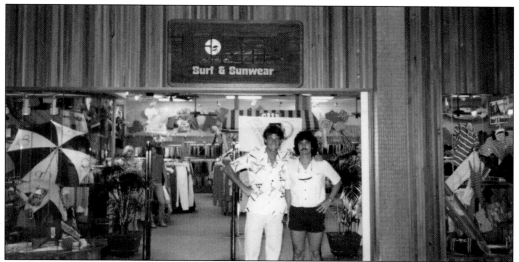

Island Surf N Sunwear shop owner John Trice, right, poses for a photograph in 1983 with visitor Shaun Tomson, one of the world's top pro surfers at the time. Trice established Island Surf N Sunwear in Corpus Christi's Padre Staples Mall in 1976. It reportedly was the first surf shop ever to operate in a mall in the United States. (Courtesy of John Trice.)

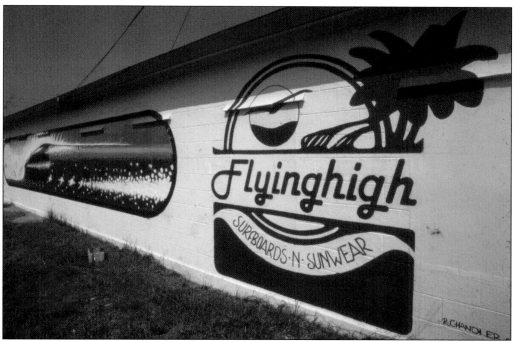

In addition to operating Island Surf N Sunwear surf shops, John Trice ran a few other Corpus Christi surf shops called Flying High. Trice went on to become president of Frost Bank-Padre Island and chairman of the Nueces County Park Board, which sets policies for area beach parks. He also served as vice president of the Corpus Christi Convention and Visitors Bureau. (Photograph by Puddy Albright.)

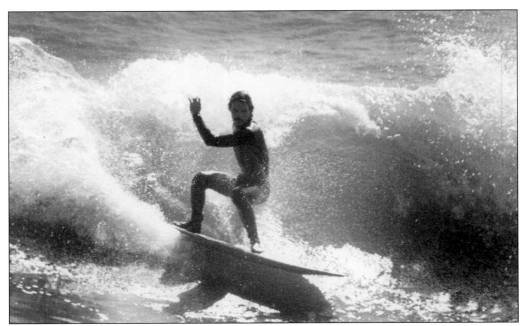

Frank Floyd slashes a wave at the Fish Pass in a 1970s-era photograph. Floyd has earned more than 20 Texas state championships in kneeboarding, surfing, and longboarding, and he has competed several times in the U.S. Surfing Championships, placing as highly as third in the senior men's division. Over the years, Floyd was active in efforts to prevent Nueces County from banning surfing near Bob Hall Pier. He opened Wind and Wave Surf Shop in Corpus Christi in 1987, and it remained in operation in 2009. Below, Floyd stands with some of the surfboard stock in his shop in 2009. (Above, courtesy of Frank Floyd; below, photograph by Dan Parker.)

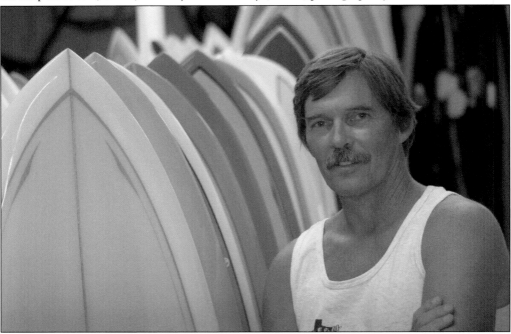

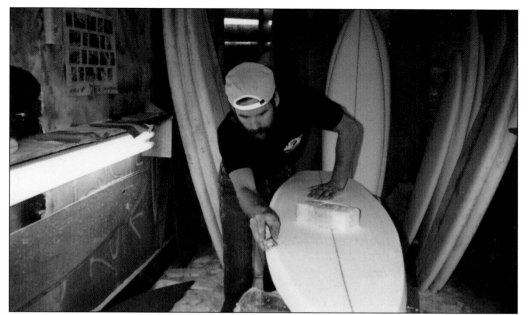

Don Murphy shapes a board at his Ocean Energy shaping bay in 1984. Murphy established Ocean Energy in 1982 and continued building boards with that label until 1996. As of 2010, he had made more than 900 boards in his shop on Oleander Street in Port Aransas. Most were custom-built boards made for individual surfers. He also sold boards out of Pat Magee's surf shop in Port Aransas. (Courtesy of Don Murphy.)

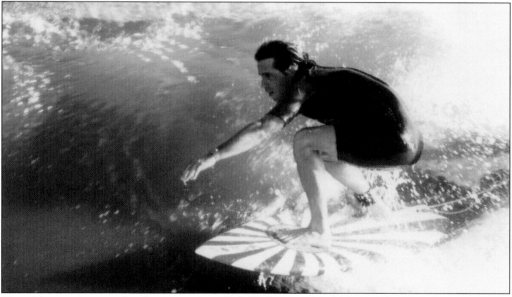

Gary Tinnerman streaks along a wave at Bob Hall Pier in a 1980s-era photograph. Tinnerman was owner and operator of Southbound Surf Shop, in the 4900 block of South Staples Street in Corpus Christi, in the late 1970s. A strong competitor at surf contests, Tinnerman also had a line of surfboards, the Tinnerman Pro Series, that was produced from 1981 to about 1990. (Photograph by David Burkhardt.)

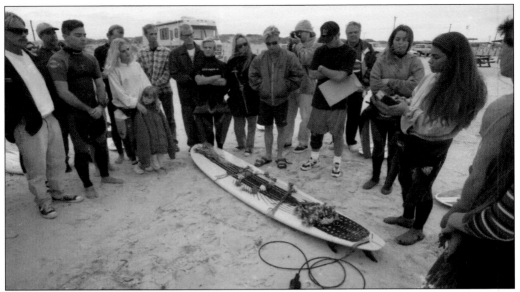

Joy Zamora, at right, reads a statement honoring Corpus Christi surfer Richard Schabe at the spot near Bob Hall Pier where he died in December 1994. Schabe, who owned the Underground Surf Depot, died of an apparent heart attack after a surf session. Friends held a small memorial service that included swimming out and releasing flowers and Schabe's empty surfboard. (Photograph by David Adame; courtesy of the *Corpus Christi Caller-Times*.)

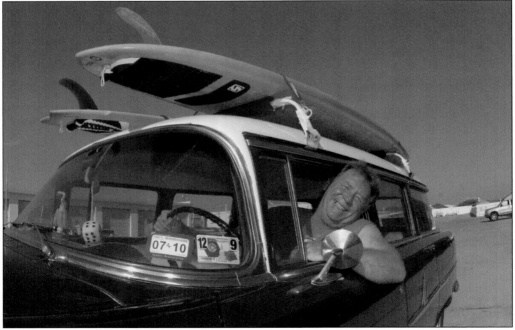

Tim Claseman sits in his 1955 Chevrolet Townsman station wagon with some boards he made himself. Claseman moved at the age of 21 to Corpus Christi from Port Huron, Michigan, in 1975. He started making surfboards in 1993 and was still at it in 2009. His operation, Mongrel Surfboards, established locations in Port Aransas and North Padre Island. (Photograph by Dan Parker.)

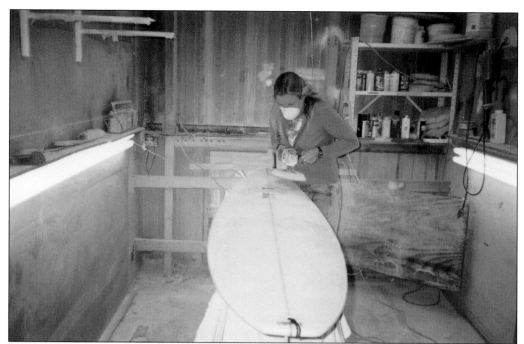

Julie Doyle fixes a ding on a surfboard at her Rodd Field Road repair facility in Corpus Christi in 2002. Doyle repaired hundreds of surfboards over the years. She also is a partner in business with her husband, Mike, a surfboard maker. Doyle became director of the Texas Gulf Surfing Association's southern district in 2006. (Courtesy of Mike Doyle.)

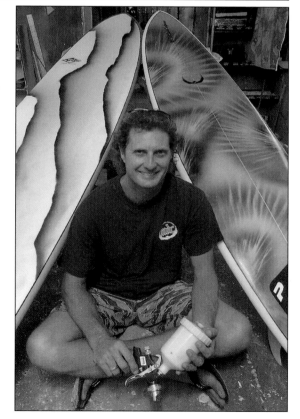

Shaper Mike Doyle, of Corpus Christi, poses for a photograph in August 2002 with two of his boards. Doyle started making boards commercially around 1985, first calling his label Total Control, then changing it to Mike Doyle Custom Surfboards. By 2009, Doyle—often confused with the champion California-born surfer of the same name—had shaped at least 4,000 boards. (Photograph by Michelle Christenson; courtesy of the *Corpus Christi Caller-Times*.)

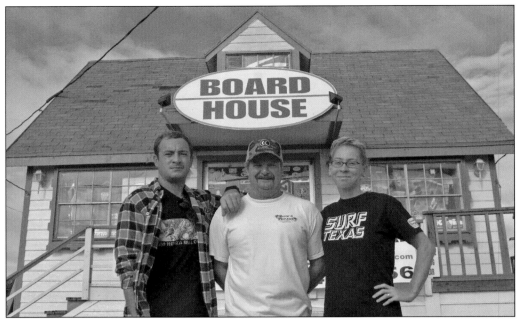

From left to right, surf shop owners Teddy Nicholson III and his father, Ted Nicholson Jr., pose for a portrait at their shop in Port Aransas with shop clerk Kate Prejean in October 2009. The Nicholsons are surfers but also raced dirt bikes in pro-am contests. Teddy III said the sports have similarities. "Definitely," Teddy said, "you have to be aware and ready. At the snap of a moment, anything can happen." (Photograph by Dan Parker.)

Chris Shannon mans his surf shop, Port A. Surf Company, in Port Aransas in September 2009. A longtime Texas surf-wear representative and surf shop proprietor, Shannon established Shannon's Sun Shop in Houston in 1978. He opened a satellite shop in Houston 14 years later, then sold both shops in 1994. He opened Port A. Surf Company in May 2007. (Photograph by Dan Parker.)

Four

STORM SURF

It would be hard to overstate the thrill that a hurricane-generated wave can produce for a Texas surfer. These are waves that generally are larger and far more powerful than the standard fare along the Gulf Coast. Depending on how one measures them, waves produced by hurricane swells can be 8, 10, 15 feet high—or even bigger.

The earliest-known story of a Coastal Bend surfer riding hurricane surf is that of Allen Blackard, who is believed to have surfed the Hurricane Carla swell in Port Aransas in 1961. Since few if any other surfers were living in the Coastal Bend at the time, Blackard probably was alone out there in Carla's massive waves as he rode a balsa surfboard he had imported from Hawaii.

Former Corpus Christi surfer Robert Rudine recalled his experience surfing the gigantic swell created by Hurricane Celia, a storm that ended up inflicting mass destruction to the Coastal Bend in 1970. He said he and a friend or two were staying in a Port Aransas hotel a few days before Celia hit.

"It was supposed to hit Freeport but at the last minute took a hard turn towards Port A.," Rudine told a Texas Surf Museum curator in an e-mail in 2009. "They woke us up in our hotel room at 6 a.m. to tell us to evacuate. Of course, we had to go surf just one more time. I paddled for an hour and was well past the end of the jetties, and it just kept breaking farther and farther out. . . . I took one wave all the way in and hitchhiked home. I was napping in my room when the roofs started going."

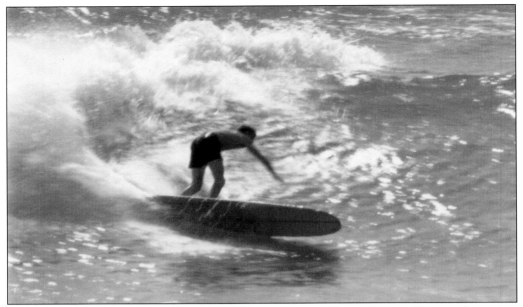

Surfing off Horace Caldwell Pier in Port Aransas, Mike Gollihar of Corpus Christi rides a wave generated by Hurricane Beulah in 1967. This is one of the earliest-known photographs of anyone riding hurricane surf on the coast of Texas. Beulah struck near the mouth of the Rio Grande River September 20, 1967, and spawned about 40 tornadoes in the Coastal Bend. (Photograph by Kent Savage.)

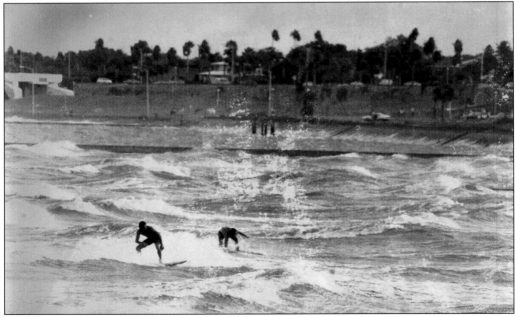

Two surfers ride small waves on the Corpus Christi bay front in 1977. There normally are no waves to ride on the bay front, but the Hurricane Anita swell changed that for a day or two. Meanwhile, Gulf-facing beaches in the Coastal Bend were pummeled by much larger waves, courtesy of Anita. (Photograph by George Tuley; courtesy of the *Corpus Christi Caller-Times*.)

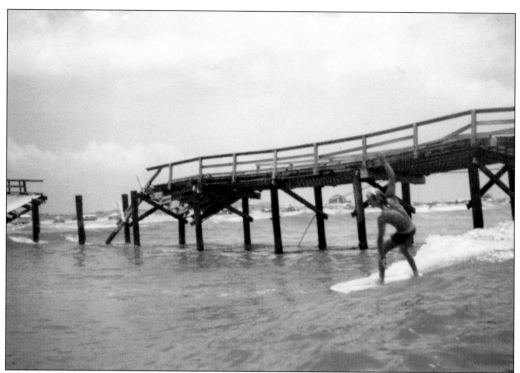

Tiger Witt surfs near the ruins of Horace Caldwell Pier in Port Aransas in 1981. The pier was heavily damaged by punishing waves pushed ashore by Hurricane Allen in 1980. The damaged pier remained in place for months before being cleared away for construction of a larger concrete pier. (Courtesy of John Vosseller.)

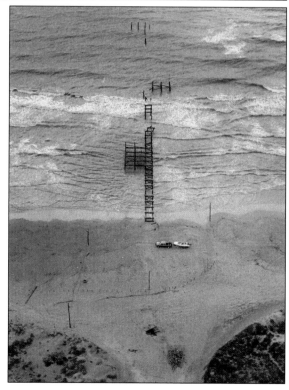

The remains of Bob Hall Pier stand on North Padre Island on August 12, 1980, two days after Hurricane Allen demolished the old wooden structure. Coastal Bend surfers enjoyed epic waves a day or two before the hurricane moved ashore near Port Mansfield. At one point, Allen was the strongest hurricane ever recorded in the Caribbean Sea, with 185-mile-per-hour sustained winds. (Courtesy of the *Corpus Christi Caller-Times*.)

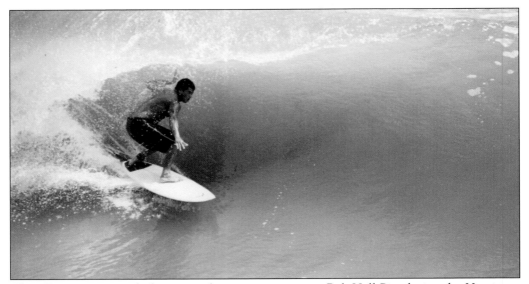

Chris Dennen gets ready for some tube time on a wave at Bob Hall Pier during the Hurricane Georges swell of 1998. Like most all Texas storm swells, the Hurricane Georges swell was produced by a hurricane that never came within 100 miles of the Texas coast but still sent quality waves to the state's shores from across the Gulf of Mexico. (Photograph by Jason LeBlanc.)

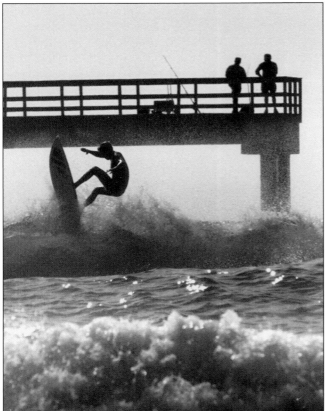

At Bob Hall Pier, an unidentified surfer gets vertical on a wave produced by Hurricane Andrew in 1992. Andrew inflicted immense destruction when it struck southern Florida August 24, 1992. The storm caused 15 deaths directly and an estimated $30 billion in property damage, making the hurricane the costliest disaster in U.S. history to that point. (Photograph by George Gongora; courtesy of the *Corpus Christi Caller-Times*.)

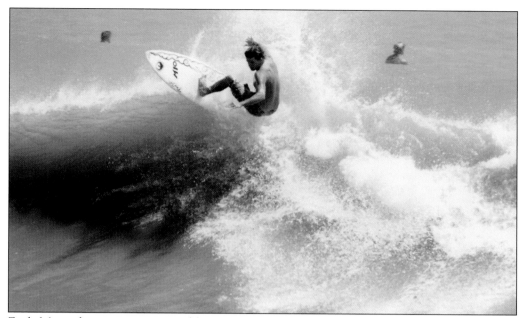

Zach May rides a wave generated by Hurricane Isidore in September 2002 at Bob Hall Pier. Isidore formed in the Caribbean Sea, entered the Gulf of Mexico between Cuba and the Yucatan Peninsula, and then churned north through the gulf before striking Louisiana. A south-to-north track through the gulf commonly brings great waves to the Texas coast, and Isidore was no exception. (Photograph by Michael Boyd.)

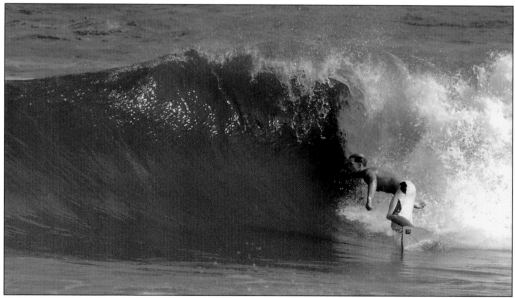

An unidentified surfer faces a vertical wall at Bob Hall Pier during the Hurricane Isidore swell in September 2002. Isidore at one point was a major Category 3 storm with 125-mile-per-hour winds, and it was expected to grow to a strong Category 4 hurricane. However, it weakened over the Yucatan Peninsula and later struck Louisiana as a tropical storm. (Photograph by David Pellerin; courtesy of the *Corpus Christi Caller-Times*.)

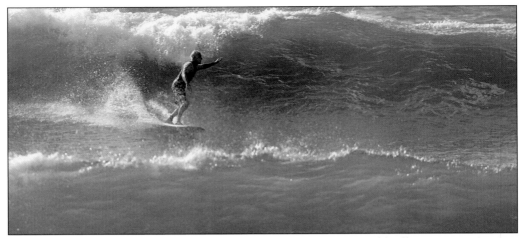

Greg Kiel of Corpus Christi rides a wave beyond the end of Horace Caldwell Pier in Port Aransas during the Hurricane Claudette swell in 2003. This photograph ran in the *Corpus Christi Caller-Times* and was picked up by the Associated Press and ran at the top of the front page of the *Houston Chronicle* and in other newspapers. (Photograph by Michelle Christenson; courtesy of the *Corpus Christi Caller-Times*.)

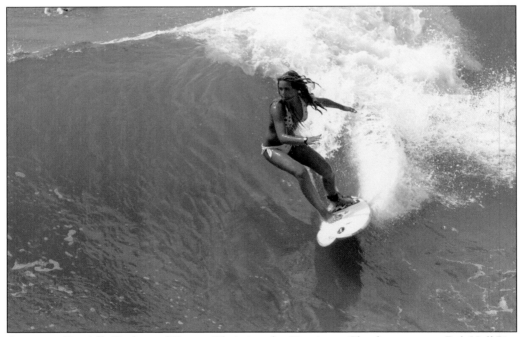

A teenage Danielle Dodson of Corpus Christi surfs a Hurricane Claudette wave at Bob Hall Pier in 2003. Five years later, she already had been on more than 10 photograph trips—paid excursions to distant surf spots, including Tahiti and the Maldive Islands, where professional photographers captured images of her riding high-quality waves. Her photographs landed in magazines, including *Foam* and *Surfing Girl*. (Courtesy of G. Scott Imaging.)

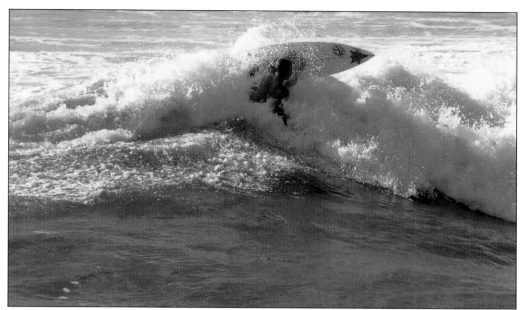

Corpus Christi siblings Olivia, Heather, Forrest, Lindsey, Vincent, Elise, and Kelly Scroggs all are surfers, and some of them have won state championships. Their parents, Randy and Sharon Scroggs, also surf. The children were homeschooled by their parents. Surfing "was the sports part of our homeschooling curriculum," Olivia Scroggs said. Above, Forrest Scroggs surfs the Tropical Storm Grace swell in August 2003. (Courtesy of G. Scott Imaging.)

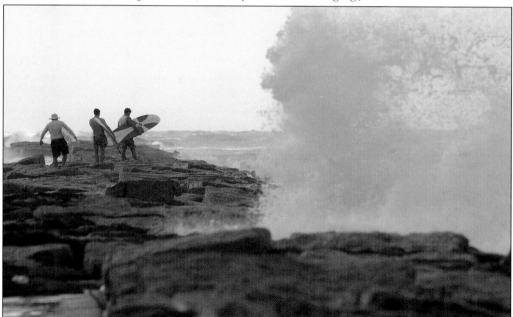

A wave crashes on the rocks at the South Jetty in Port Aransas as three surfers look for a spot to jump into the surf during the Hurricane Erika swell on August 16, 2003. Surfers walking up Texas jetties during hurricane swells must watch out for big waves that sometimes roar completely over the rocks. (Photograph by Michelle Christenson; courtesy of the *Corpus Christi Caller-Times*.)

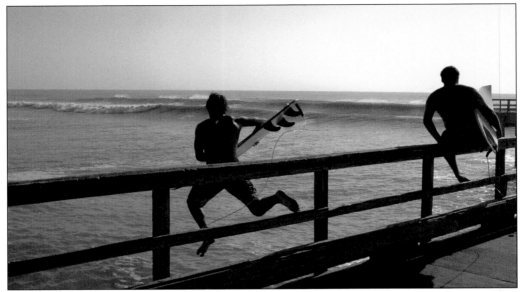

A surfer leaps from Bob Hall Pier as waves produced by Hurricane Ivan approach in September 2004. Hurricane swells can produce such steady, powerful surf on Coastal Bend swells that surfers sometimes have jumped off piers to avoid the frustration of paddling out through punishing waves. Ivan was the 10th most intense hurricane ever recorded in the Atlantic Ocean or Gulf of Mexico. (Photograph by Michael Boyd.)

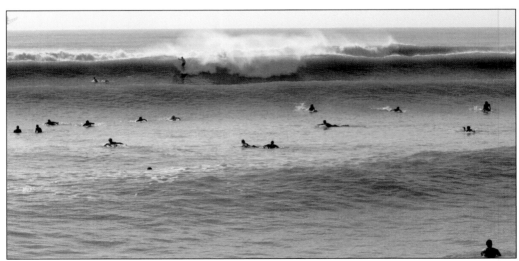

Surfers jockey for position as a set of waves pours through the area of Bob Hall Pier during the Hurricane Ivan swell in 2004. Taking an unusual path, Ivan churned north through the Gulf of Mexico, struck Alabama, and moved across the southeastern United States before entering the Atlantic Ocean and looping back into the gulf again, producing a second Ivan swell in Texas. (Photograph by Mark Norris.)

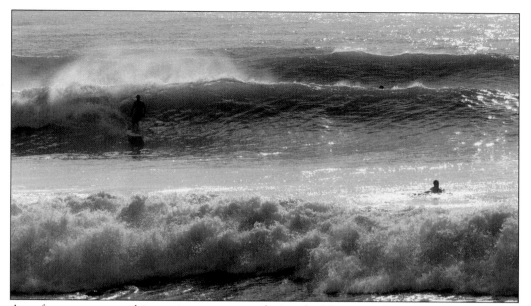

A surfer cuts across a shimmering waterscape during the Hurricane Dennis swell at Bob Hall Pier in July 2005. Dennis emerged near the beginning of a hurricane season that produced 28 named storms, including 15 hurricanes, seven of which were major. It was the busiest hurricane season in decades, creating the best surf conditions Texas surfers had seen in years. (Photograph by Mark Norris.)

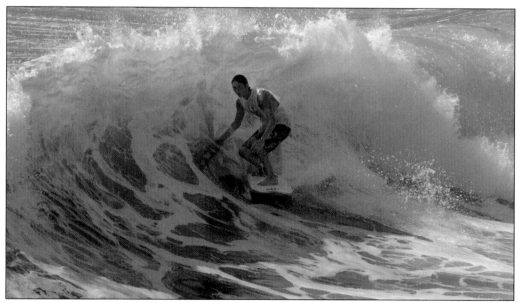

Ryan Cobb surfs at Bob Hall Pier during the Hurricane Dennis swell on July 11, 2005. Cobb, of Corpus Christi, won the Texas state championship in the junior men's division of the Texas Gulf Surfing Association in 2002 and 2003. His father, Ty Cobb, and uncle, Johnny Cobb, were veteran surfers of the Coastal Bend scene. (Courtesy of G. Scott Imaging.)

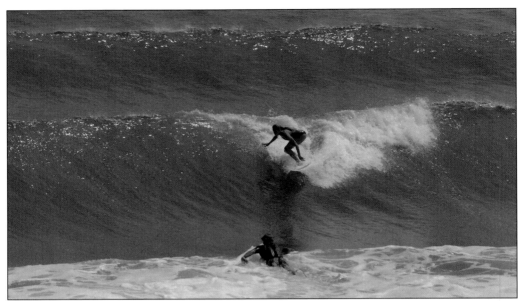

Above, Nicole Hagopian of Corpus Christi drops into a nice wave during the Hurricane Rita swell in 2005. Hagopian took state championships in the women's shortboard division in the 2007–2008 and 2008–2009 competition years. Nicole and her relatives were a surfing family from the mid-1970s through the new millennium. Surfing family members included Nicole's father, Charlie; her grandmother, Marcia; Nicole's brothers, Caleb and Germain; her uncles, Cliff and Chris; her aunts, Melinda and Liz; and cousins Adam, Shaun, and Sheena Hagopian and Angie and Chris Franks. Below, Charlie Hagopian rides the 2002 Hurricane Isidore swell at Bob Hall Pier. An amateur shaper, Charlie had made about 100 surfboards by 2009, and most all of the many surfers in his family had ridden his boards. (Above, courtesy of G. Scott Imaging; below, photograph by Michael Boyd.)

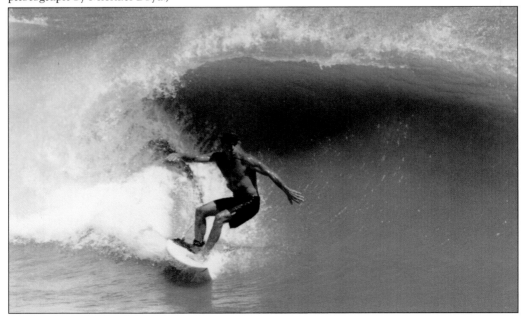

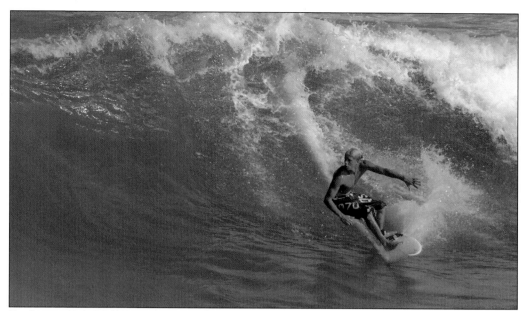

Surfing at Bob Hall Pier, Corpus Christi's C. J. Bradshaw punches a bottom turn on a wave produced by Hurricane Katrina on August 28, 2005. Katrina sent large, powerful waves and strong riptides that sucked some surfers far offshore. Surfers off Port Aransas were rescued by the Coast Guard. Katrina famously plowed into Louisiana, where it ended up killing more than 1,800 people. (Courtesy of G. Scott Imaging.)

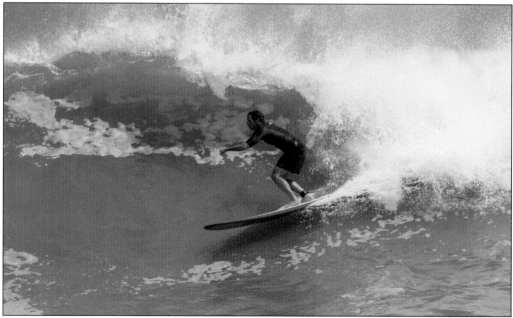

Steve Schuster of Corpus Christi races the cascading lip of a Hurricane Katrina–generated wave at Bob Hall Pier in 2005. Katrina roared ashore in Louisiana as a Category 3 hurricane on August 29 with top winds estimated at 125 miles per hour. The storm's damage costs topped $50 billion along the northern Gulf Coast. (Photograph by Mark Norris.)

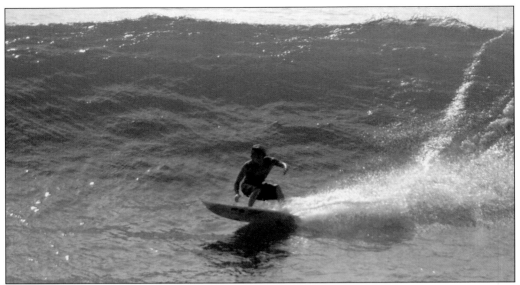

Jarrett Frazier drives off the bottom of a Hurricane Rita wave at Bob Hall Pier in 2005. Rita prompted one of the largest evacuations in U.S. history. While some in the Coastal Bend evacuated, the biggest exodus occurred farther north, in the more populous Houston and Galveston areas. Rita made landfall on September 24 in the area of the Texas-Louisiana border. (Photograph by Michael Boyd.)

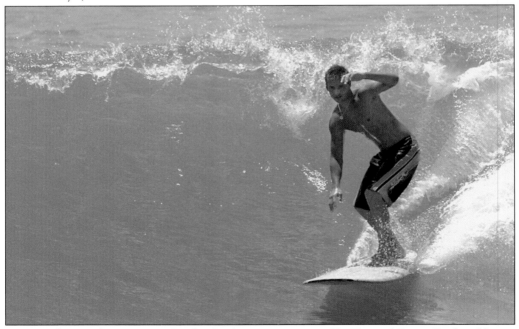

Corey Williams, who grew up in Portland, rides a wave generated by Tropical Storm Cindy at Horace Caldwell Pier in Port Aransas on July 6, 2005. Williams scored multiple longboard championships in Texas in the new millennium and also placed well at bigger contests in California, Florida, and Hawaii. He also worked as a surf instructor all over the country. (Photograph by Michelle Christenson; courtesy of the *Corpus Christi Caller-Times*.)

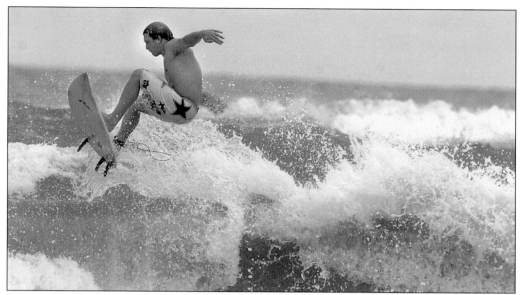

Waves propelled by Tropical Storm Erin had Chris Hoelscher jumping for joy at Bob Hall Pier on August 17, 2007. In the new millennium, surfers in Texas and beyond were able to predict when storm swells would reach the coast and just how powerful they would be by checking buoy readings and other information sources on the Internet. (Photograph by Todd Yates; courtesy of the *Corpus Christi Caller-Times*.)

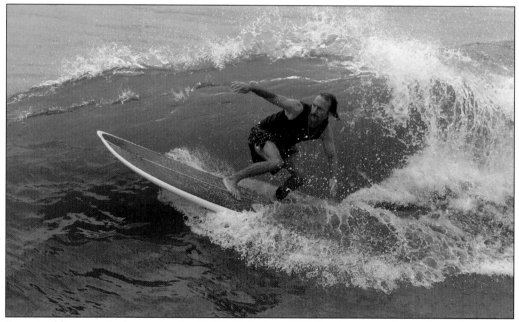

Energized by a tropical wave in the Gulf of Mexico, Cliff Strain carves the pocket of a wave at Horace Caldwell Pier in Port Aransas on July 27, 2007. Strain, of Port Aransas, began working as a teacher in the nearby Flour Bluff Independent School District in 1990, establishing an oceanography program at the district's intermediate school. (Photograph by Michelle Christenson; courtesy of the *Corpus Christi Caller-Times*.)

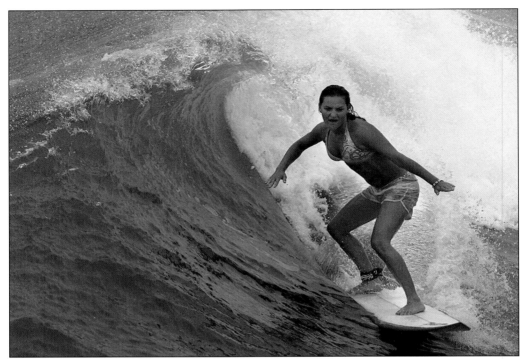

Alicia Yaklin, a biology and chemistry student at Texas A&M University-Kingsville, surfs at Horace Caldwell Pier during a tropical disturbance July 27, 2007. "Surfing is the most soul-freeing, exhilarating activity I've ever experienced," Yaklin said in an interview with the Texas Surf Museum. "I'm sure every surfer would agree that, no matter how much you surf, it's never enough." (Photograph by Michelle Christenson; courtesy of the *Corpus Christi Caller-Times*.)

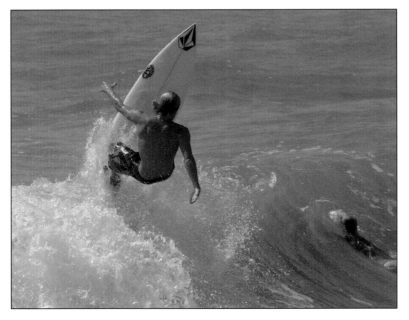

Jarrett Frazier hits the lip of a wave during the Hurricane Dean swell at Bob Hall Pier on August 24, 2007. Frazier said the active hurricane season of 2005 was the most striking year of surfing the Texas coast has experienced. The Hurricane Dennis swell was especially memorable. "Just perfect," he said. "No wind, waves overhead and just firing." (Courtesy of G. Scott Imaging.)

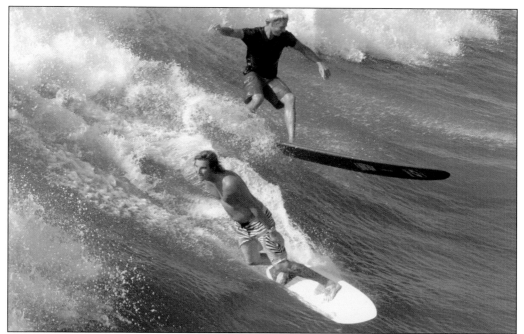

Nick Jones (foreground) rides the Hurricane Ike swell at Horace Caldwell Pier on September 11, 2008. Ike's approach to the Texas coast prompted many in the Coastal Bend to board up their houses and evacuate, but the storm ended up striking the Galveston area, about 200 miles north along the coast. It was the third most destructive hurricane ever to hit the United States. (Photograph by Murray Judson; courtesy of the *Port Aransas South Jetty*.)

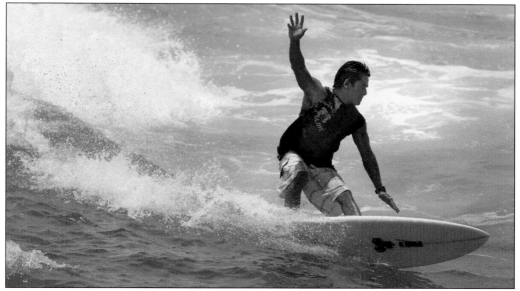

Rene Lopez of Port Aransas surfs the Hurricane Dolly swell of 2008 at Horace Caldwell Pier. The Hurricane Rita swell of 2005 impressed Lopez more, with the tide so high that waves reached the top of the pier. "I shot the pier at one point and slapped my hand on the underside of the pier slab," Lopez said. (Photograph by Michelle Christenson; courtesy of the *Corpus Christi Caller-Times*.)

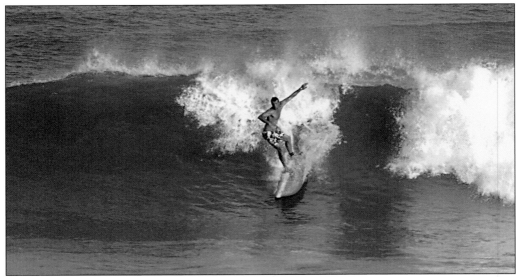

Cody Underwood surfs in Port Aransas during the Hurricane Gustav swell September 1, 2008. While Gustav delivered some of the best waves in years to Coastal Bend surfers, its approach to Louisiana unnerved residents in that state, where Hurricane Katrina had caused so much destruction three years earlier. But Gustav ended up not being anywhere as serious as Katrina. (Photograph by Dan Parker; courtesy of the *Port Aransas South Jetty*.)

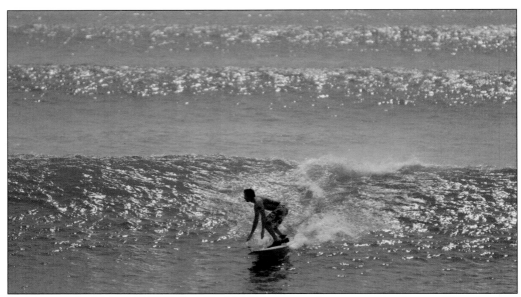

An unidentified surfer rides the first in a set of waves marching up to the shores of Port Aransas during the landmark Hurricane Gustav swell on Labor Day 2008. Gustav brought long, perfectly sculpted waves more than 8 feet high to the Coastal Bend in one of the best swells to strike the area in three years. (Photograph by Michelle Christenson; courtesy of the *Corpus Christi Caller-Times*.)

Five

SURF CONTESTS

Surf contests started in the Coastal Bend within a few years after significant numbers of people started surfing the region in the early 1960s. Competitive organizations sprang up: the Gulf Coast Surfing Association, the Gulf Surfing Association, the Texas Surfing Association, and then the Texas Gulf Surfing Association. Coastal Bend surfers competed with each other, with surfers from the northern and southern coasts of the state, and with surfers from California, Hawaii, and East Coast states.

Coastal Bend surfers at times beat their counterparts from other parts of the country, even though the Lone Star state did not have consistent waves for training. Corpus Christi residents Donna Self, Julie Polansky, Kevin Tansey, John Olvey, Rita Crouch, and Tippy Kelley won national championships. Layne Harrison of Corpus Christi and Morgan Faulkner of Port Aransas distinguished themselves with strong finishes in pro contests on the East and West Coasts. In 1987, before Florida's Kelly Slater won a record nine world surfing championships, more than any other surfer in the world, Corpus Christi's Jimmy Curry beat Slater in a preliminary round of the U.S. Surfing Championships.

Coastal Bend surfers also have achieved top ranks as administrators of national competitive surf organizations. RoxAnne Bowen-Schlabach of Corpus Christi served as head tabulator for the U.S. Surfing Federation. Her husband, Cliff, was president of the Gulf Surfing Association in 1986 and 1987 and cofounder of the Texas Gulf Surfing Association in 1988. He served as statewide president of the TGSA from its inception to 2004 and was a surf contest judge beginning in 1985 and continuing on until at least 2009. Schlabach was vice president of the U.S. Surfing Federation from 1988 to 2000. Tippy Kelley of Corpus Christi and Don Murphy of Port Aransas were founders of the Texas Gulf Surfing Association in 1988. Carolyn Adams of Corpus Christi moved to California in 1985 and later became executive director of the National Scholastic Surfing Association.

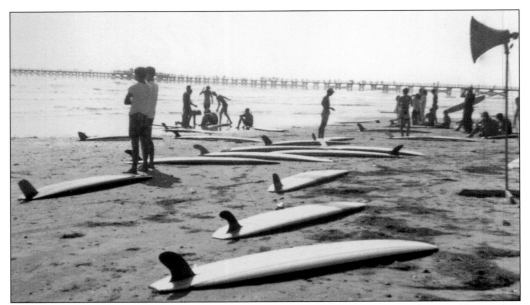

Surfboards lie scattered at a Coastal Bend surf contest held in 1967. A speaker used by contest organizers is visible at right. If any of the boards in this photograph remained in existence in the new millennium, they were worth many hundreds or possibly a few thousand dollars each to collectors of classic surfboards. (Photograph by Mary Lou Williams.)

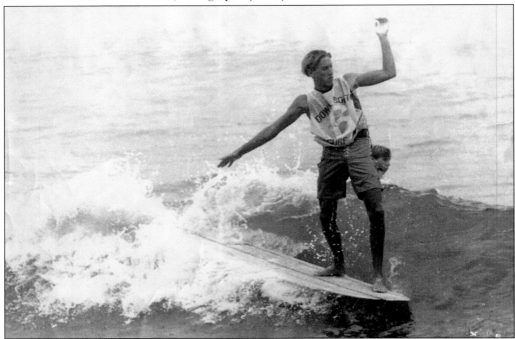

Scott Volz of Houston rides the nose during a Down South Surf Carnival contest in the mid-1960s in Port Aransas. Like other contestants, Volz was wearing a contest jersey that was custom made for the Down South Surf Carnival by the Birdwell firm of California. Down South surf contests attracted surfers from all over Texas and beyond. (Courtesy of Jeannine Gilliland.)

Judges of a Down South Surf Carnival contest view competitors from the back of a truck on the beach in Port Aransas in 1966. In the truck are, from left to right, John Price, owner of Surfboards Hawaii; Down South Surf Shop owner Tony Mierzwa (standing); Bryson Williams, owner of B. J's surf shops; and Brent Flower, of Down South. (Courtesy of Tony Mierzwa/Down South Collection.)

Contestants line up at the Down South Surf Carnival, a surfing competition in Port Aransas in 1966. More than 40 years after the contest, several veteran Texas surfers could not agree on the identities of everyone in this photograph, but they did agree that Armond "Doc" Jones is third from left and that Pat Magee is fifth from left. (Courtesy of Tony Mierzwa/Down South Collection.)

Judges view contestants from atop scaffolding on the beach in Port Aransas during the Port Aransas-St. Joseph's Island Surfing Championships in 1968. In the foreground, heat sheets are posted on a board to show the results of the contest so far. Among sponsors of the contest were the city of Port Aransas, Loe Surfboards, and Custard's Last Stand. (Photograph by Johnny Roberts.)

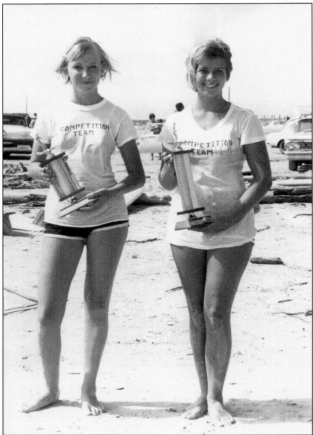

Donna Slaughter (left), of Corpus Christi, and Paulette Just of Port Aransas show trophies they won at a Port Aransas surf contest in the early 1960s. Slaughter and Just were among the very first female competitive surfers in the Coastal Bend. (Courtesy of Paulette Just/Egeli.)

From left to right, Adam Wojtascyk stands on the beach at Surfside with surf contest official Carolyn Snyder Adams and Wes Beck, all of Corpus Christi, at a Surfside surf contest in 1981. Adams moved to California in 1985 and later became executive director of the National Scholastic Surfing Association, an organization that ran surf contests around the United States for children and teenagers while also promoting academic achievement. (Photograph by Michael Boyd.)

Larry Bertlemann surfs during the first round of the finals of the Sundek Texas Classic surf contest. A Hawaiian, Bertlemann was one of the most skilled and innovative surfers in the world at the time. Floridian Matt Kechele, another one of the world's top pros, narrowly beat Bertlemann in the finals to win a $4,000 purse. (Photograph by Tom Hand; courtesy of the *Corpus Christi Caller-Times*.)

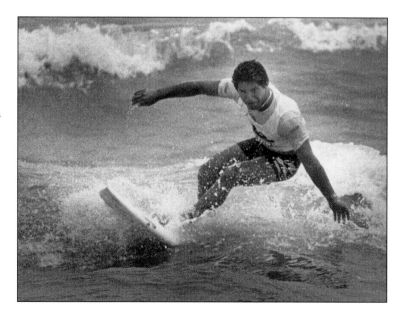

Spectators watch early part of the Sundek Texas Classic contest at J.P. Luby Surf Park on March 29, 1984. Later, the waves got bigger, and so did the audience. Each surfer who completed a ride prompted loud applause and yelling from the crowd. (Photograph by Lee Dodds; courtesy of the Corpus Christi Caller-Times.)

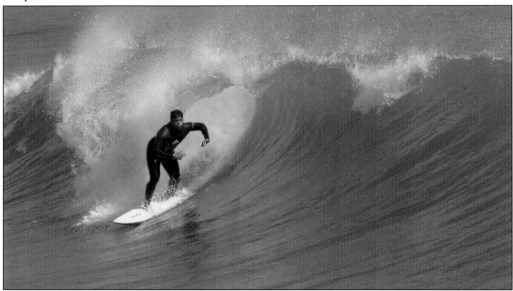

Chris Dennen surfs some cold but beautiful water at Bob Hall Pier on January 17, 2004. From 1989 to 1995, Dennen won many surf contests, scoring several Texas state titles. In 1995, he beat Floridian Damien Hobgood, one of the world's top amateurs at the time, in the U.S. Championships at South Padre Island. (Courtesy of G. Scott Imaging.)

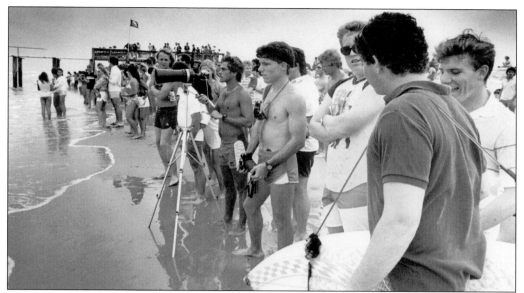

A crowd watches the Sundek Texas Classic at J.P. Luby Surf Pier on North Padre Island on April 1, 1984. Frank Floyd of Corpus Christi was the director of the contest, described as the first major pro surf competition ever held in Texas. Corpus Christi's Island Surf N Sunwear shop brought in some of the nation's top pros for the event. (Photograph by Lee Dodds; courtesy of the *Corpus Christi Caller-Times*.)

Mark Foo of Hawaii hangs out at the Texas Offshore Pro surf contest on North Padre Island in April 1987. Famed as a highly photographed big-wave rider, Foo was one of the sport's top figures at hallowed Waimea Bay, the Oahu home of waves more than 30 feet high. Foo died in 1994 after falling from a 15-foot wave at Maverick's, a Northern California break. (Photograph by Diane Matzke Griffith.)

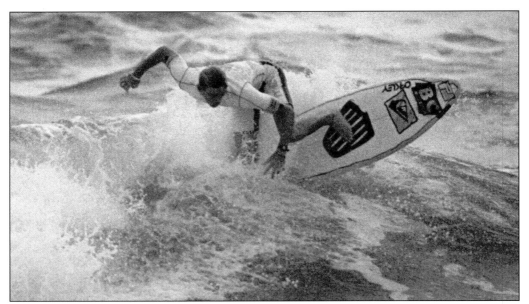

A surfer hits the lip of a wave on the first day of the U.S. Surfing Championships at J. P. Luby Surf Pier in 1987. The contest started with uneven, shoulder-high waves. After a front hit, the contest was moved a few miles south to a spot known as Million Dollars, where the north wind cleaned up the wave form nicely for competitors. (Photograph by Erich Schlegel; courtesy of the *Corpus Christi Caller-Times*.)

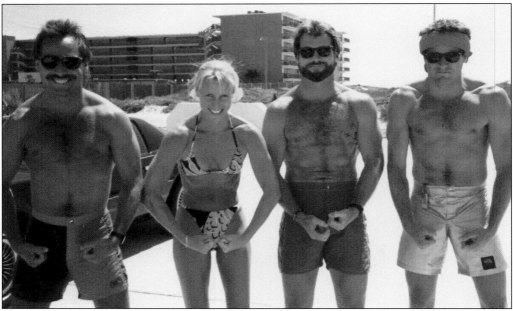

From left to right, Louis Ros of Florida, Diane Matzke of the upper Texas coast, Ken Bradshaw of Hawaii, and Jesse Fernandez of Florida clown on North Padre Island during the Texas Offshore Pro surf contest in 1987. Bradshaw got started as a surfer in Texas and had become an internationally known big-wave rider in Hawaii by the time this photograph was taken. (Courtesy of Diane Matzke Griffith.)

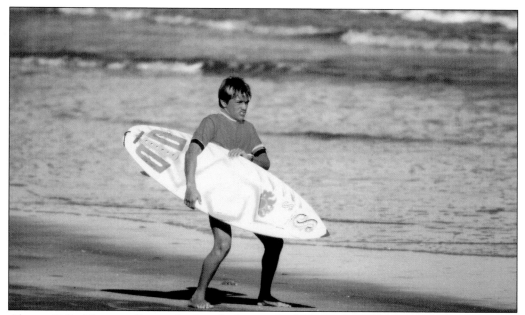

Above, Kelly Slater walks up the beach during the U.S. Surfing Championships held at the North Padre Island seawall in 1987, when Slater was a teenager. The native Floridian eventually won a record nine world surfing championships, more than any other wave rider. At this contest, however, he was beaten by Jimmy Curry of Corpus Christi in a preliminary round, allowing Curry to make the 10-man U.S. team. Curry had already won a few Texas state championships by the time he took out Slater. Once he made the national team, he helped represent the United States in a world contest in Puerto Rico. Below, Curry slashes a wave at Bob Hall Pier on September 23, 2004. (Above, photograph by David Burkhardt; below, photograph by Michael Boyd.)

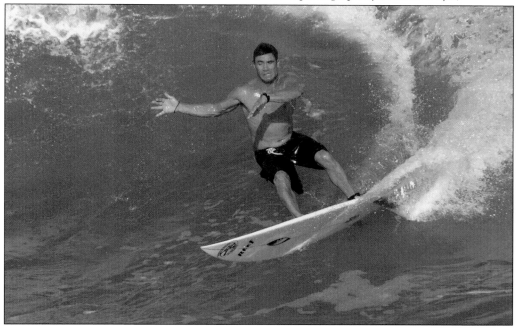

At left, Corpus Christi surfer RoxAnne Bowen-Schlabach tabulates scores at a Texas surf contest in the late 1980s. RoxAnne and her husband, Cliff Schlabach, played integral parts of the Coastal Bend surf scene for years. RoxAnne worked from 1985 to 2004 for the Gulf Surfing Association and then the Texas Gulf Surfing Association as the organizations' head tabulator. She was head tabulator for the U.S. Surfing Federation from 1988 to 2000, each year traveling around the country to the U.S. Surfing Championships. RoxAnne won two state championships herself in the late 1980s. Below, RoxAnne styles on a wave at Mustang Island State Park on May 9, 1998. (Left, photograph by Tamela Herr; below, photograph by David Adame, courtesy of the *Corpus Christi Caller-Times*.)

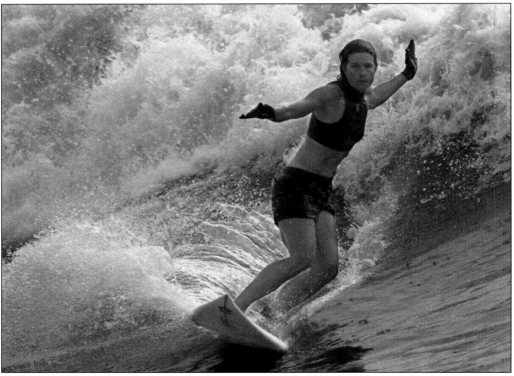

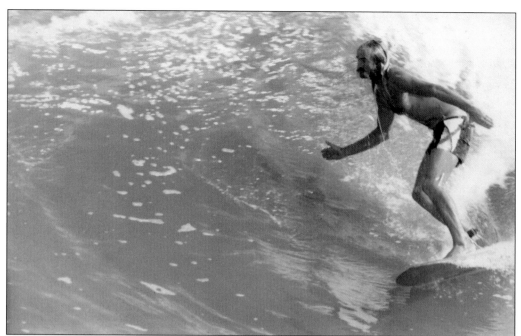

Above, Cliff Schlabach, of Corpus Christi, rides a wave in Port Aransas during the Hurricane Juan swell of 1985. Schlabach started riding waves in 1963 in Port Aransas when he lived in the inland town of Refugio. From 1985 to 1990, he took four state surfing championships and one state paddleboarding championship. He was president of the Gulf Surfing Association in 1986 and 1987 and cofounder of the Texas Gulf Surfing Association in 1988. He served as statewide president of the TGSA from its inception to 2004 and was a surf contest judge beginning in 1985 and continuing on until at least 2009. Schlabach was vice president of the U.S. Surfing Federation from 1988 to 2000. At right, Schlabach takes notes while judging a 1980s Texas surf contest. (Above, courtesy of Cliff Schlabach; right, courtesy of Frank Floyd.)

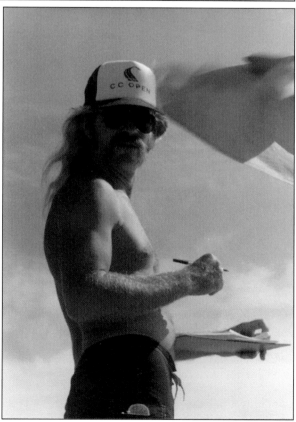

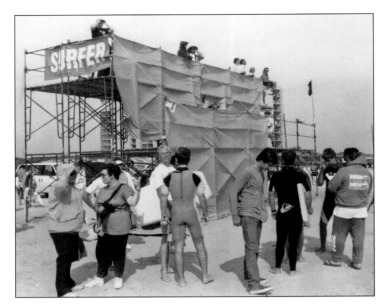

Scaffolding for judges and contestants stands on the beach in Port Aransas for the 1991 U.S. Amateur Surfing Championships. The event drew about 400 nationally ranked surfers from around the country. The contest also prompted a visit by Texas governor Ann Richards, who mingled with surfers and posed with them for photographs on the beach. (Photograph by Murray Judson; courtesy of the *Port Aransas South Jetty*.)

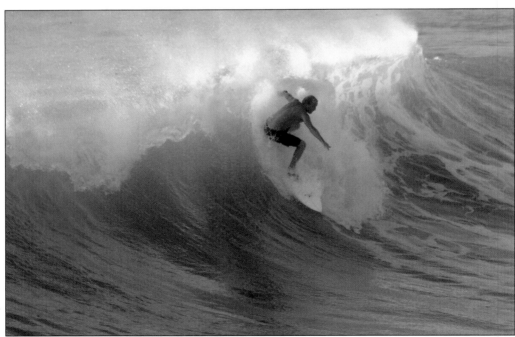

Tripp Howse, of Corpus Christi, drops into a wave during the Hurricane Grace swell on August 31, 2003. Howse was the Texas Gulf Surfing competition director during a portion of the 1990s. "There are kids out there who are not team-oriented. They're their own individuals," Howse said once. "Surfing allows them to be that person." (Courtesy of G. Scott Imaging.)

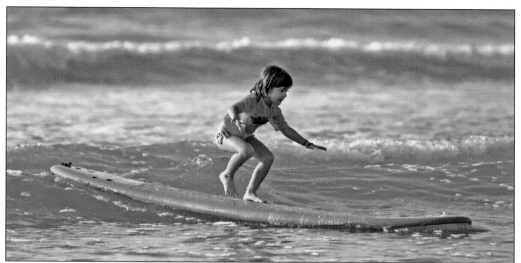

Four-year-old Caitlin Shannon walks the deck of her board during the third annual Ashlyn Shoemaker Memorial Grom Roundup in Port Aransas in September 2007. The kids' surf contest was sponsored in part by the Ashlyn Would Go Foundation for Futures—a nonprofit group established in memory of Ashlyn Shoemaker, a 14-year-old Galveston surfer who died suddenly of a heart ailment in 2005. (Photograph by Dan Parker; courtesy of the *Port Aransas South Jetty*.)

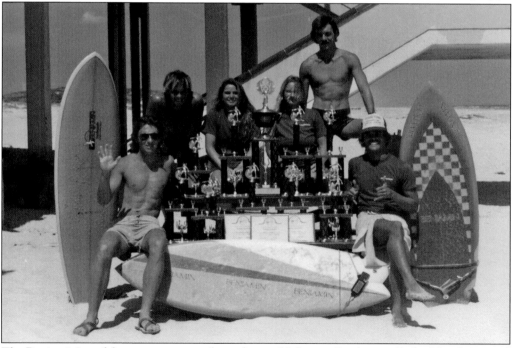

The Benjamin's surf shop team poses with trophies at Malaquite Pavilion on Padre Island National Seashore in 1982. From left to right are Michael Boyd, Kevin Tansey, Stacy Bynum, Lanette Boyd, Frank Floyd, and Cisco Torres. The Benjamin's team took first place in the state while competing in Texas Surfing Association contests for a few years in the early 1980s. (Courtesy of Michael Boyd.)

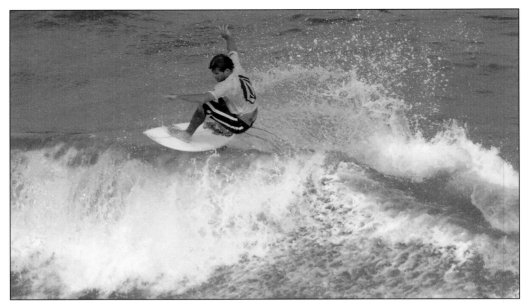

Zach May, of Corpus Christi, surfs at the Volcom surf contest at Bob Hall Pier on September 20, 2003. May won at least five state championships, among many other honors, between 1988 and 2008. He has surfed on the Dockside, MD Surf and Skate, and Wind and Wave surf teams. (Courtesy of G. Scott Imaging.)

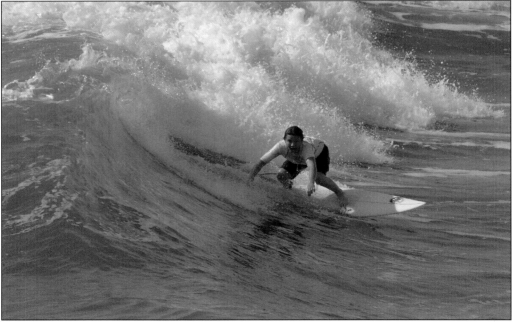

Nine-year-old Nathan Stolley, of Corpus Christi, surfs at a Texas Gulf Surfing Association contest at Horace Caldwell Pier in Port Aransas March 8, 2009. By October 2009, Nathan had taken state championships three times in the mini-groms division and once in the micro-groms division. His father, Mark Stolley, won a state championship in 1987. Mark's brothers, Chris and Brian, also have been stand-out Texas surfers. (Courtesy of G. Scott Imaging.)

Six

ORGANIZATIONS

Surfers are known for being free spirits, riding waves on their own and playing by their own rules. But they have been known to band together, whether it is to form a club or a competition team or an organization that runs surf contests. Surfers also have schooled together to form community action groups.

Surf clubs were most popular in the 1960s, when the Coastal Bend Surfing Association, Santana Surf Club, Santa Monica Surf Club, San Blas Surfing Association, South Wind Surf Club, and Kanaka Surf Club all formed in the Coastal Bend. Clubs had their own logos, and members dressed in color-coordinated jackets and trunks.

Sponsored mostly by surf shops, surf teams have existed for decades in the Coastal Bend. Some teams have repeatedly taken honors at surf contests up and down the state. In the 1970s and 1980s, surfers got together and attended meetings of the Corpus Christi City Council and Nueces County Commissioners' Court in efforts to ease a ban on surfing next to Bob Hall Pier. In related efforts, surfers conducted voter registration drives on the beach.

In 2004, Corpus Christi–area surfers formed a new chapter of the Surfrider Foundation, a national organization that protects beach-access rights and water quality.

In 2005, the Texas Surf Museum opened in Corpus Christi, providing a gathering place for historic preservation efforts and for celebrations of the Lone Star State's surfing heritage. For its grand opening, the museum flew special guest Dorian "Doc" Paskowitz into Corpus Christi from his home in Hawaii and presented him with a city proclamation honoring him. One of the earliest-known Texas surfers, Paskowitz got his start riding waves in Galveston as a child in the 1930s.

In 2006, Coastal Bend surfers flexed their political muscle like never before, joining up with Corpus Christi's Beach Access Coalition to successfully lobby city voters to reject a ballot measure that would have allowed closure of 7,200 feet of North Padre Island beach to vehicular traffic, making access more difficult.

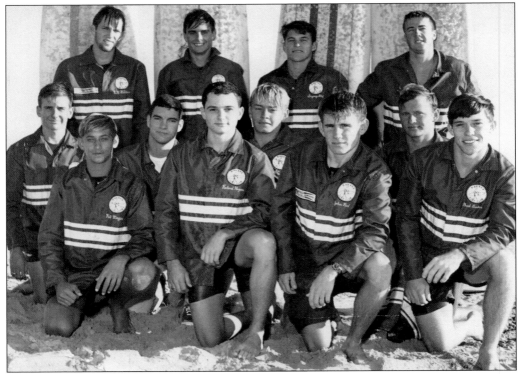

Wearing their matching jackets and trunks, members of Corpus Christi's Kanaka Surf Club pose for a portrait in 1965. From left to right, they are (first row) Pat Magee, Roland Hogan, Johnny Peel, and Fred Tucker; (second row) Terry Gill, Dewayne Catchings, Danny Hunsaker, and Tony Mierzwa; (third row) Billy Kohler, Brent Flower, Greg Kiel, and Pat Jewel. (Courtesy of Pat Magee.)

Members of Corpus Christi's South Wind Surf Club horse around on the beach while posing for a photograph in the early 1960s. Club members included Ed Bounds, Jane Bryson, Harold Cobb, Allan and Jim Dinn, Larry Laws, Linda Laws, Tony Mierzwa, Anna McKenzie, David Pennick, Susan Rhodes, Arthur Rios, Pete Scott, Jan Vutech, John White, Bill Wolf, Janice Richardson, Al Roach, and Donna and Jerry Slaughter. (Courtesy of Pat Magee.)

Seen here from left to right are Patti Knox, Janice Richardson, DeDe Hunsaker, Dorothy Turnbull, and Moina Clymore showing off their Texas State Surfing Championships T-shirts during a meeting of the Coastal Bend Surfing Association's girls' team in 1966. All of the girls were from Corpus Christi except for Turnbull, who lived in Port Aransas. (Photograph courtesy of Dorothy Turnbull Hill.)

Members of the Coastal Bend Surfing Association gather for a portrait at the Corpus Christi home of Marvin Harper (far right, standing), the benefactor of many young Coastal Bend surfers in the 1960s. Harper, who owned the Surf Shack in Port Aransas, was known for giving surfer kids rides when he drove his van each morning from Corpus Christi to the beaches of Port Aransas. (Courtesy of Pat Magee.)

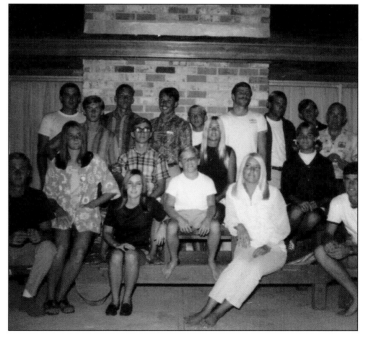

The Island Sports Surf Team of Port Aransas displays some of its surf contest trophies in 1989. From left to right, they are (first row) Bobby Hall, Rick Darling, and John Garlington (second row) Don Murphy, Gene Gore, and John Johnson. In 2004, Gore and his wife, Rachel, paddled a 12-foot paddleboard 404 miles, along the entire Texas coast, to raise money for the Surfrider Foundation. (Courtesy of Don Murphy.)

Corpus Christi's Dockside Surf Team poses for a photograph in 1998. Seen here from left to right are (first row) Jason Neil, John Olvey, Justin Jackson, and Johnny Haas; (second row) shop owners Tippy and Patrick Kelley, Chris Stolley, Zach May, Jesse Fleig, and Chuck Emmons. (Courtesy of Patrick Kelley.)

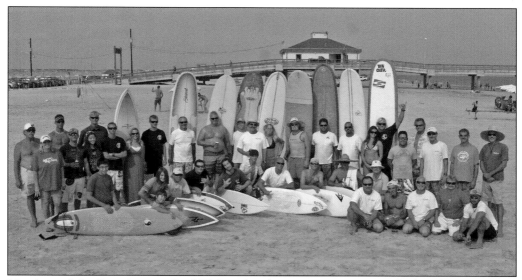

Members of the Port Aransas Surf Club gather for a group portrait on the beach near Horace Caldwell Pier in September 2009. Don Murphy, Bill Mann, and Shawn Wollerman founded the club in the early 1990s. Red surf trunks are the unofficial uniform of the club, which possessed more than 50 members in 2009. (Photograph by Dan Parker.)

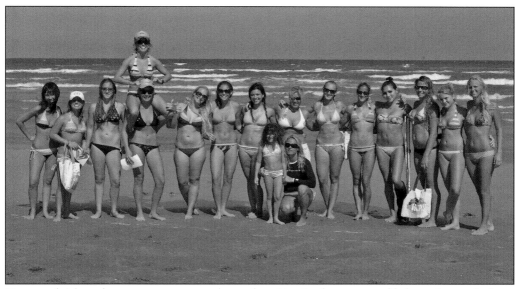

Dozens of girls and young women turned out when Lisa Andersen, a world champion surfer from Florida, visited Mustang Island to seek out recruits for her national Roxy surf team in 2006. Andersen, kneeling, poses here for a photograph with prospective team members. (Courtesy of G. Scott Imaging.)

Young surfer John Trice, at right, confers with friend John Jordan and Nueces County commissioner Carl Bluntzer during a meeting of the Commissioners' Court in the early 1970s. Trice and other surfers had banded together to lobby county officials for the right to surf next to Bob Hall Pier. Jordan, whose son was a surfer, was there to help support the surfers' cause. (Photograph by Doug Kinsley.)

Folks mill through the Art Museum of South Texas in Corpus Christi during the 1999 opening of an exhibit called Surfin' Art. All of the paintings, photographs, sculptures, and other artwork were created by surfers. The Ventures played surf music at the opening. The exhibit drew the highest attendance in the museum's decades-long history. (Courtesy of Ron Randolf.)

Surfer Mike McCutchon holds a map of Padre Island while talking to reporters at Corpus Christi City Hall on March 16, 2006. McCutchon was spokesman for the Beach Access Coalition, a surfer-heavy organization that successfully fought a developer's proposal to close more than a mile of beach to vehicles in 2006. McCutchon was a Corpus Christi city councilman from 2007 to 2009. (Photograph by George Tuley; courtesy of the *Corpus Christi Caller-Times*.)

At Corpus Christi City Hall in November 2006, Neil McQueen, president of the Corpus Christi chapter of the Surfrider Foundation, reads a statement to the press during a Beach Access Coalition rally to get out the vote to preserve the right to drive on a large chunk of North Padre Island beach. Many Surfrider Foundation members were part of the Beach Access Coalition. (Courtesy of G. Scott Imaging.)

Cliff Schlabach helps a blind woman, Jan Gates, 56, of Oklahoma, along the beach at Mustang Island State Park on June 19, 2003. It was in 1998 that Schlabach and his wife, RoxAnne Bowen-Schlabach, began running annual events in which surfers from the Corpus Christi area worked as volunteers, introducing dozens of mentally and physically disabled folks to the thrill of surfing. (Photograph by Michelle Christenson; courtesy of the *Corpus Christi Caller-Times*.)

Chelsea Pinson, a 12-year-old blind girl from Oklahoma, takes off on a wave with the help of surf instructors Donald Bowen and RoxAnne Bowen-Schlabach at Mustang Island State Park on July 29, 2001. It was Pinson's first time to try surfing. (Photograph by Michelle Christenson; courtesy of the *Corpus Christi Caller-Times*.)

Texas Surf Museum owner Brad Lomax in 2005 checks out one of the museum's surfboards, a 60-year-old board that is the oldest known to have been made in Texas. Lomax started the museum in 2005 after purchasing most of the extensive collection of classic surfboards and surf memorabilia owned by Pat Magee of Port Aransas. (Photograph by George Gongora; courtesy of the *Corpus Christi Caller-Times*.)

Legendary surfer Dorian "Doc" Paskowitz cuts the ribbon at the grand opening of the Texas Surf Museum in Corpus Christi in 2005. From left to right are Liz Lomax, Corpus Christi Hispanic Chamber of Commerce representative Joe Cisneros, museum cofounder Pat Magee, pro surfer Robert "Wingnut" Weaver of California, Paskowitz, California-born former world champion surfer Mike Doyle, *Endless Summer* star Robert August, and museum cofounder Brad Lomax. (Courtesy of G. Scott Imaging.)

Longtime surf shop owner Kathryn Williamson cuts the ribbon on a new exhibit about Texas women surfers at the Texas Surf Museum in June 2008. Standing with Williamson were, from left to right, Julie Polansky, Tippy Kelley, Donna Self, Karen MacKay, Jody Whilden Blumenfeld, and Grace Clark Knowles. All were Texas surfers, and all (excepting Blumenfeld) had won national championships. (Photograph by Michelle Christenson.)

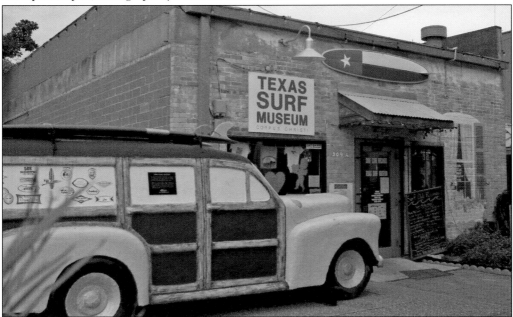

Founded in 2005, the Texas Surf Museum stands at 309 North Water Street in Corpus Christi. The only surf museum in Texas, the institution celebrates the general history of surfing and focuses on the Lone Star State's unique place in that history. The museum displays a wide variety of surf memorabilia, including vintage surfboards and hundreds of photographs in rotating exhibits. (Photograph by Dan Parker.)

THE TEXAS SURF MUSEUM

Since opening its doors on June 3, 2005, the Texas Surf Museum in Corpus Christi has worked hard to preserve the surfing history of the Lone Star State. Museum representatives have gathered and catalogued thousands of Texas surf photographs from dozens of sources located throughout Texas and around the world. The museum also has collected Texas-made surfboards and many other pieces of Texas surf memorabilia and has commissioned several short documentary films telling the history of Texas surfing. Keeping the museum's displays fresh, curators periodically create new exhibits and bring in high-profile surfers from around the country for public appearances. Admission, like the waves, is free at the museum, but supporters are encouraged to make donations to keep the institution alive and on its mission to preserve Texas surf history. The surf museum is located at 309 North Water Street in downtown Corpus Christi and can be reached by telephone at 361-882-2364.